Berta and Elmer Hader

A Lifetime of Art

Oceans of love from Aunt Berta and Uncle Elmer

Berta and Elmer Hader
A Lifetime of Art

By
Joy Hoerner Rich, Karen Tolley,
John Waller, and Judy Waller

Joyful Productions
Roseburg, Oregon

Berta and Elmer Hader
A Lifetime of Art

Cover and interior designed and composed by Judy Waller, using Adobe Illustrator CS4. Text set in Adobe Minion with headings in Myriad. Printed by Shelton Turnbull Printers, Inc. in Eugene, Oregon, on Pacesetter Silk 100 lb. text.

Publisher's Cataloging-in-Publication data
Berta and Elmer Hader: a lifetime of art / Joy Hoerner Rich … [et al.].
p. cm.
ISBN 978-0-9891087-0-6
Includes bibliographical references and index.
1. Hader, Berta. 2. Hader, Elmer, 1889–1973. 3. Hader, Berta—Criticism and interpretation.
4. Hader, Elmer, 1889–1973—Criticism and interpretation. 5. Illustration. 6. Artists—Biography.
I. Joy Hoerner Rich. II. Tolley, Karen. III. Waller, John. IV. Waller, Judy.
NC975.H4 2013 741.6—dc23 2013906238

Published by Joyful Productions
P.O. Box 1106
Roseburg, Oregon 97470

Printed in the United States of America.

This book is dedicated lovingly to the memory and legacy of Berta and Elmer Hader, illustrators and authors who inspired generations of children.

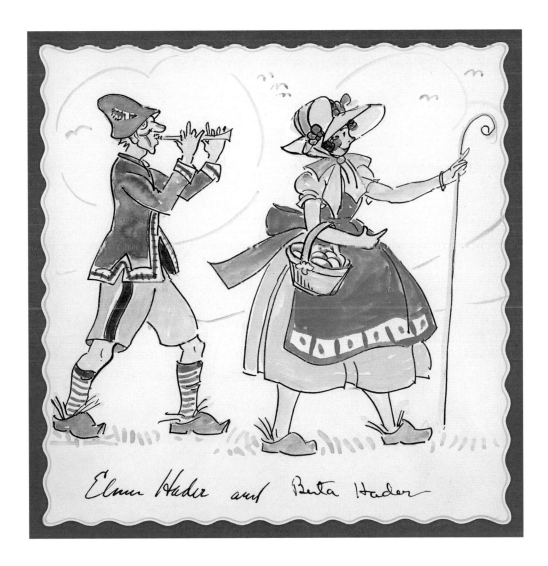

Elmer Hader and Berta Hader

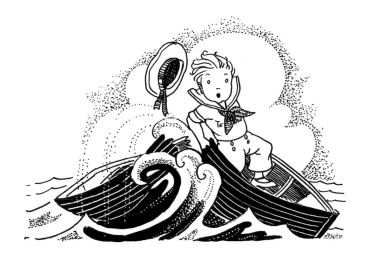

Contents

Foreword

What made and makes the Hader books so admired and loved? The Haders gained the respect of children, adults, librarians, and, now, collectors, not through a series of devices, tricks, attention getters, and clever promotion. Rather, they reached their readers through a genuine appreciation and understanding of nature. Their work is timeless, sincere, and candid. The Haders were able to tell a story with a simple message and a specific purpose, yet without the need to moralize. They captured the songs of birds in spring, the peace of animals in hibernation, the effect of a silent snow, and the love of a child for all things good and honest. Their regard for human life, their concern for animal welfare, and their reverence for the outdoors—all are apparent to the reader of any age and of any time.

The Haders charmed us when we were children poring over their works. Very likely it was in part because of our love for their artwork and stories that we both became librarians, with one of us even specializing in the working files of children's writers and illustrators of the Golden Age of Children's Literature. As adults, we discovered that Berta and Elmer Hader were even more charming in person than we ever could have imagined.

Our visits with Berta and Elmer at their home on Willow Hill were magical. Conversations ranged far and wide—from current events to an observation about a creature within or outside their storybook home. Elmer's eyes always shone as Berta grew ecstatic over the next project or local happenings.

As guests at the Little Stone House, we passed along news about other creative artists, such as James Daugherty, Hardie Gramatky, Kurt Wiese, or Elizabeth Orton Jones, who had told us the how and why of their works. But the focal point always returned to Willow Hill. And then Berta and Elmer would share something as simple as an ingredient added for the first time to the day's soup.

Berta and Elmer not only shared meals and conversation with us, but they also embraced our goals. They understood what we were trying to do: to document the creative efforts and developmental thoughts, successful or not, of twentieth century American writers and illustrators of children's literature. We were interested in preserving records revealing an artistic career and creative development. We were seeking correspondence with friends, agents, editors, and readers—all those people

with whom the authors or illustrators exchanged thoughts, problems, ideas, and personal feelings about how well the work was or was not going. We were looking for drafts, notes, research files, sketches, dummies, and manuscripts.

On the completion of each book, Berta carefully assembled correspondence, sketches, several versions of the dummy layouts with rough illustrations and pasted text, page proofs, and whatever else was associated with the book's creation. Arrangements were made for those items to be housed at the Special Collections department at the University of Oregon. The Haders contributed materials related to fifty-eight of their books and many other items of both professional and personal nature. Berta's efforts those many years ago are a dream for researchers today who chronicle the Haders' work.

It is with great pleasure, then, that we turn the pages of this new publication. We're eager to see all of our old friends and familiar places once again, whether they be a chipmunk, goat, squirrel, mouse, the Nyack Library, Willow Hill, or the Hudson River. And, of course, we're most happy to be with Berta and Elmer once more as they work, play, and share their appreciation and respect for all forms of life.

Ed and Elaine Kemp
Retired Librarians at the University of Oregon
Friends of Berta and Elmer Hader

Preface

Berta and Elmer Hader sat together at their drawing tables on the "stage," bathed in the gentle north light pouring through the floor-to-ceiling windows of the rambling stone house on Willow Hill, near Nyack, New York, that they built with their own hands. They worked on their current children's book, passing their art boards back and forth in a truly collaborative creative effort. Outside, the birds chirped and the creatures of the surrounding woods roamed, perhaps knowing that inside that big house lived two people who liked them enough to write stories about them.

This collection has been compiled by four people who admire and respect Berta and Elmer Hader's art, writings, and exemplary lives. One of us, Joy Hoerner Rich, is their niece, who, with her siblings and later her own children, was the dedicatee of several of the Haders' books. Joy and other family members freely shared their memories of the Haders to include in this book.

Further research for *Berta and Elmer Hader: A Lifetime of Art* included a visit to Willow Hill, interviews with former neighbors and friends of the Haders, plus research sessions in the San Francisco Public Library, the Nyack Library, and the Rockland Historical Museum. We pored over Hader materials still in the family's keep and those at the University of Oregon and the University of Southern Mississippi. Research findings led us to people who, through phone calls and correspondence, helped us to learn more about Berta and Elmer. At every turn, we found helpful people championing our efforts.

Our writing team would have been a team of five but for the untimely death of our friend Bill Duncan. He was a writer throughout his life. He was awestruck by Berta and Elmer's accomplishments. He knew this story had to be told, and he helped us to know we were capable of the telling.

A major goal, and difficult task, was selecting the art to include: There was much from which to choose. We wanted the art to reflect the range of the Haders' styles and abilities. We included some specific information about their artistic technique, but labored over selecting pieces from the extensive body of their works, which will convey more than our words ever could.

We accessed the Haders' original artwork for scanning whenever possible. This assures the most brilliant colors and sharpest details and allows us to do full justice to Berta and Elmer's magnificent work. It also allowed us to avoid the printing problems resulting from scanning art from the

books printed with halftone dots. Many of the original art boards, after being used by the publishers and printers and being stored for decades, have stains and smudges. Except for the most egregious artifacts, we have made only minimal adjustments to the scans in order to retain the character and authenticity of the Haders' original artwork.

A second goal was to create a book that was not only delightful, but also informative and easy to use. Thus, the reader will encounter reference numbers within the text that refer to the References, Credits, and Notes section at the back of the book. We have combined our cited references and bibliography into one numbered list, arranged alphabetically, beginning on page 133. The reference numbers in the text refer to the items on this list with the corresponding numbers. Though this is an unconventional format, we believe it will best assist the reader in easily accessing the reference cited. We have also included a Glossary to define terms related to the Haders' book production and art.

Information is provided not only in the text, but also within the image captions. Occasionally abbreviations are used. "U of O" stands for the University of Oregon. "SC" stands for solander case. Many Hader materials are available for the public to see. The items shown in this book which are housed in an institution and available for public viewing are so noted within the caption. Hader materials owned by an individual are listed as being in a private collection. There are hundreds of pieces of Hader art available to view which are not reproduced in this book. Please refer to the Archives listing on page 138.

Berta and Elmer had an ever-evident sense of whimsy. We have attempted to capture that "theme of whimsy" in a variety of ways. Many of the Hader books and all of their Christmas cards were hand-lettered by either Berta or Elmer. The hand-lettering on the Haders' annual Christmas cards inspired the style of the large initial capital letter for each chapter. We believe that readers unfamiliar with the Haders are about to enjoy getting to know them, and those who are familiar with their works are about to have a pleasing, nostalgic experience.

The north light in the Haders' quaint studio in their little stone house helped them to see clearly when creating their art. But it was their love of life that helped them to clearly see beauty all around them and moved them to create that art, some of which is now being offered here for a new generation to experience and enjoy.

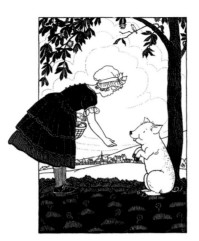

Introduction

Berta and Elmer Hader were two talented people who met in their twenties, fell in love, married, and forged a career that was to produce thousands of pieces of art, scores of children's books, and hundreds of paintings and sketches. Their style ranged from the impressionistic and whimsical to the realistic. The mediums they used included oils, gouache, watercolors, pastels, pen and ink, and graphite and colored pencils.

Each had an arts career before they met, but the merging of their lives and talents produced a wealth of illustrations rich with color and detail. Both their art and their words told stories. They so delighted in pictorial presentation that they were famous amongst their friends and peers for illustrating notes and letters, travel diaries and, occasionally, the shopping list. Their annual Christmas cards were, of course, handmade works of art.

Once, when they had missed an editorial deadline, rather than write an apologetic note to their editor, they produced a sixteen page, fully illustrated bound book detailing Elmer's bout with the flu and recovery. [22] That personalized book was created for Louise Seaman Bechtel, their first Macmillan editor. It is archived with her personal papers at Vassar College. There was an edition of one.

Their children's books, fifty-four of which they both authored and illustrated and thirty-seven of which they illustrated for others, were produced in dozens of editions and in many languages. Their charming art won them Caldecott Honors twice and the coveted Caldecott Medal, awarded to the illustrator(s) of a distinguished children's picture book, once, in 1949.

Mary Margaret McBride, a renowned national radio personality of the twentieth century, was a friend of the Haders and wrote, "When I tell people about Berta and Elmer they think they are a figment of my imagination." [53] Their lives were full of laughter and love; deep abiding friendships; and dedication to honoring the earth, its animals and its people through actions, writings and art.

When asked why they'd chosen a career in the writing and illustrating of children's books, they responded, "We write and illustrate books for children in the hope that pictures and stories will: 1) Interest and amuse our young readers. 2) Awaken and cultivate a kindly feeling toward other children, as well as the birds and domestic animals about the house and the gentle creatures of field and forest, who share the world they live in. 3) We write for children, not to preach, nor moralize, but

to suggest that the world about them is a beautiful and pleasant place to live in, if they but take time out, to look. And perhaps in so doing, our young readers will develop an interest to save what is good of their world for others to enjoy." [26]

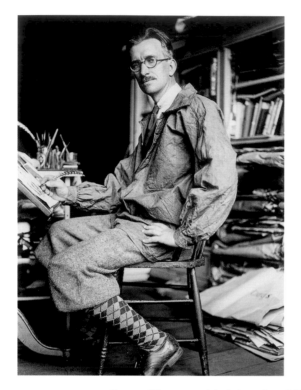
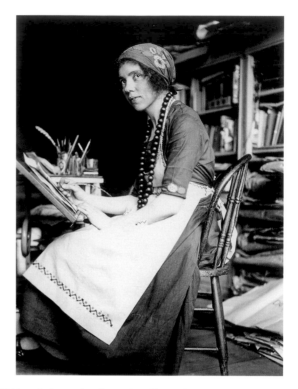

Berta and Elmer at work in their studio at Willow Hill. Note their use of quill pens (see Glossary). Photographers unknown. Private collection.

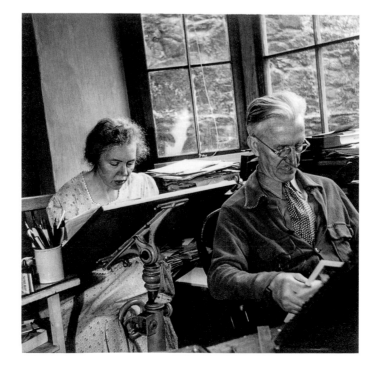

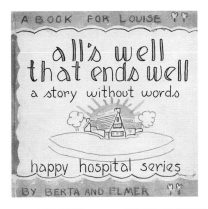

All's Well That Ends Well.
Berta and Elmer Hader.
Unpublished, undated.
Unique, hand-painted book created for
editor Louise Seaman Bechtel as an
explanation for a missed deadline.
Collection Vassar College, Louise Seaman
Bechtel Collection.

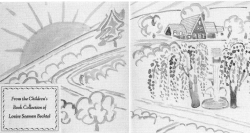

1.

2.

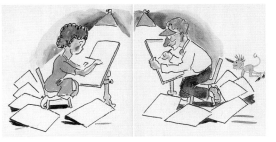

3.

4.

5.

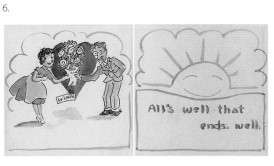

6.

7.

8.

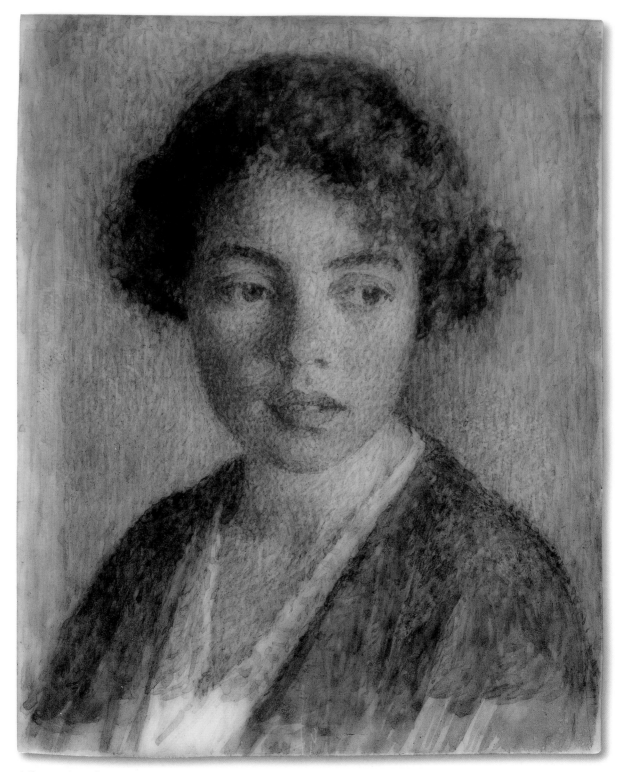

Self-portrait (one of Berta's miniature portraits painted on a thin slab of ivory)
Date and place of creation unknown.
Gouache on ivory.
Actual size 1⅝" x 2⅛" (enlarged here to show detail).
Collection U of O, AX441 (Addenda), Box 5, Folder: Miniatures, Item 11.

1
Berta before Elmer

Berta Hoerner's parents moved to Mexico to join relatives in a business venture, and there Berta was born. When asked, her mother would tell people Berta was born in 1890, but Berta always claimed her birth year as 1891. The family moved to Texas where her brother, Godfrey, was born in May of 1893. Sadly, their father, Albert, passed away in 1895. Berta's mother, Adelaide, moved with the children to Kansas City for a while, but then moved again to be with her parents in Suffern, New York. She became a charity worker to support herself and her two children (today we would call her a social worker). Berta attended school in Suffern and then at the Ethical Culture School in New York City. Later the three moved to Cleveland, Ohio, where Berta graduated from high school. Adelaide met her second husband there, William Gordon, and in 1909 the family of four moved to Seattle, Washington.

Both Adelaide and her mother were artistic and nurtured Berta's love of art. Adelaide's mother painted oils and Berta's mother did watercolor sketches all of her life. Berta often shared the memory that a friend of her mother's hired her to draw a book of Sunbonnet Babies when she was about ten. (Sunbonnet Babies were popular depictions of little girls whose faces were always hidden from view by large sunbonnets, created by Bertha Corbett. Their charm may have inspired some of Berta's later artwork for children.) Adelaide sent Berta to an artist's studio to study drawing during the summer vacation that she was nine or ten. Berta also remembered that in third grade her teacher appointed her the class artist, illustrating lessons on the chalkboard for all the class to see. That same year she won a writing contest. The prize was a copy of *Tom Sawyer*, a book Berta loved and was thrilled to receive. It seems that this experience strengthened another interest: writing. [19]

Berta matured into a tall and willowy young woman with beautiful brown eyes and a great big heart. A friend would later say that Berta was the recipient of hundreds of confidences never given to anybody else. [54] Another friend said that Berta had a warm and attractive personality: "…in this she was outstanding. She always gave the impression of charm." [57]

After high school Berta decided to pursue her second passion and enrolled at the University of Washington School of Journalism. While a student, she took a part-time job with the Western Engraving and Colortype Company, where she developed skills in layout and art design for printing. Eva Shepard, her supervisor at Western Engraving, also did fashion drawings for the newspaper

advertisements of two major department stores. It was Eva who introduced Berta to fashion illustration and to her sister Clare who was friends with and model for Imogen Cunningham. Imogen worked for Edward Curtis, the well-known photographer of the American West and of Native American people. Imogen later became a famous photographer herself. Through Clare, Berta met Imogen, and the two became lifelong friends. Clare was an accomplished painter of exquisite miniature portraits, deftly painted with gouache on very thin slabs of ivory. Berta determined to learn this technique. It was a perfect medium for her talents, with her incredible eye for detail and her delicate hand. Berta became happily immersed in art and left the journalism program.

Eva moved to San Francisco in 1913, and Berta took her place contracting with the Seattle department stores of Frederick & Nelson and The Bon Marché, doing fashion drawings for their advertisements. In 1915 Eva decided to relocate to New York and encouraged Berta to move to San Francisco and assume her contract with the *San Francisco Bulletin*. Berta did move to San Francisco, where she worked with the *Bulletin* as a fashion artist and became a student at the California School of Design. Her love of art flourished.

Berta's first residence in San Francisco was an apartment on Russian Hill, the same apartment house which was home to three soon-to-be friends: Bessie Beatty, Katherine Anne Porter, and Rose Wilder Lane.[64] Fame lay ahead for Bessie as a foreign correspondent, magazine editor, and celebrated radio personality. Katherine's writing skills would earn her a Pulitzer Prize as well as three nominations for the Nobel Prize in Literature. Rose was to become a recognized writer and was the daughter of Laura Ingalls Wilder, author of the Little House on the Prairie books. It was Berta who later showed Laura's writings to the right editor and opened the door to Laura's literary successes.[43]

Berta and Bessie decided to pool their resources and move to a small rustic home up on Telegraph Hill, paying $5 per month in rent. The house was made from redwood timbers, which had been used in a huge sign facing the bay, welcoming home the Great White Fleet, sixteen U.S. battleships circumnavigating the world in 1907. The new residence, which was on Montgomery Street, also served as a studio and was visited regularly by other young and artistic folks living on Telegraph Hill. Rose rented a little house right next to Berta and Bessie's studio. Years later, in 1925, Rose wrote to Berta saying that she'd just visited the old neighborhood and "because of our being part of the original T.H. artistic bunch we are apparently legends now." There was definitely a "Spirit of the Hill" of which the studio had been an integral part.[49]

Bessie Beatty was editor of the women's page at the *Bulletin*. She recognized the talents of her young friends and was pleased to give them work. Bessie traveled to Russia in 1917 where she remained for nearly a year serving as a foreign correspondent for the San Francisco newspaper. Rose Wilder Lane, like Bessie, did a great deal of traveling in her writing career. Years later, in a letter to Rose, Laura Ingalls Wilder wrote of her fond memory of visiting her in California and meeting her curly-haired friend Berta for the first time. She thought of it whenever she heard the sound of eucalyptus "nuts" hitting a tin roof.[73]

Berta always seemed to be a magnet for youngsters. The studio on Telegraph Hill became a favorite haunt for many of the children of the immigrant settlers who lived nearby. She would entertain them with parties, presents, stories, and by drawing pictures for them. One tale she liked to tell was about a neighbor's burro from her growing-up days. Someone had told her that the burro belonged to her and she liked to believe it was true.[16] Much of her early work in miniature painting consisted of studies of these young neighbors. Seeds for a lifetime career in children's artwork were sown on Telegraph Hill.

Berta was an industrious young woman willing to take chances on opportunities that came her way. She was careful to develop the skills needed to be successful in each opportunity. She was outgoing and friendly in a quiet sort of way, making friends easily and remaining loyal to them throughout her life. Berta had probably decided that life was pretty good. She was making a living doing what she loved: art. She was selling her miniatures, and her work at the *Bulletin* had gone from contract work for fashion design to illustrating a series of feature stories as an artist on staff. She was surrounded by other creative and interesting people. Then one day in 1916 there was a knock on her door. She opened it, and there stood an attractive, artistic young man with his easel, brushes, and paints in hand: Elmer Hader.

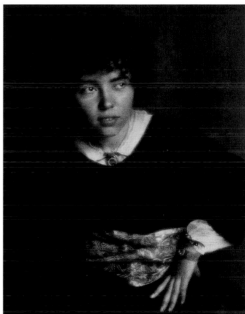

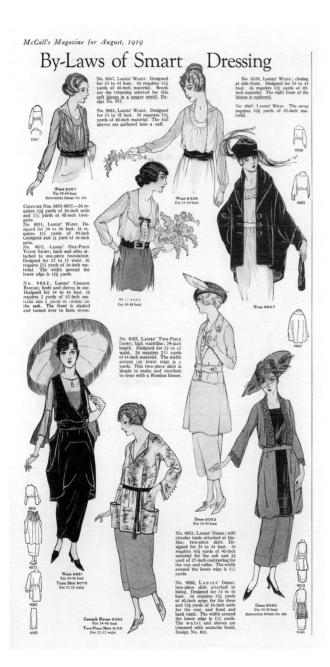

Portrait of Berta Hoerner by her life-long friend, Imogen Cunningham (1909). Original print in Berta and Elmer's private collection. Reprinted with permission, © 2013, The Imogen Cunningham Trust. Collection Concordia University–Portland.

Berta's tracing paper sketch for a fashion illustration Collection U of O, AX441, Addenda, SC 4, Fashion drawings.

Fashion illustrations were typically done by freelance artists who were not credited. The illustrations to the left are scanned from *McCall's Magazine,* August, 1919, during the time when Berta was doing fashion illustration for the magazine. Comparing the style of these drawings to that of Berta's children's pages and other magazine illustrations, it seems safe to assume that her drawings would have looked much like these, and indeed they may be Berta's.

Hand-painted Valentine from Berta to her mother
Adelaide and stepfather William Gordon.
Pen and ink with watercolor.
Collection Concordia University–Portland.

Illustrated letter from Berta to her mother.
Pen and ink with watercolor.
Collection Concordia University–Portland.

Berta's preliminary sketch for a miniature portrait.
Pencil on paper.
Actual size 1½" x 2".
Collection U of O, AX441 (Addenda), Box 5, Folder:
Miscellaneous sketches.

Berta's preliminary sketch for a miniature portrait.
Pencil on paper.
Actual size 2½" x 3".
Collection U of O, AX441 (Addenda), Box 5, Folder: Miscellaneous
sketches.

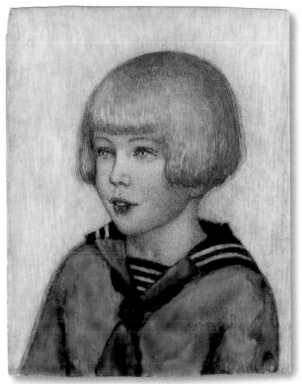

Detail from portrait at left.

One of Berta's miniature portraits.
Actual size 2" x 2½".
Gouache on thin slab of ivory.
Collection U of O, AX441 (Addenda), Box 5,
Folder: Miniatures, Item 13.

One of Berta's miniature portraits.
Actual size 1½" x 2".
Gouache on thin slab of ivory.
Collection U of O, AX441 (Addenda), Box 5,
Folder: Miniatures, Item 2.

One of Berta's miniature portraits.
Actual size 2½" x 3⅜".
Gouache on thin slab of ivory.
Collection U of O, AX441 (Addenda), Box 5,
Folder: Miniatures, Item 7.

Henry Hader (Elmer's father)
Elmer Stanley Hader, San Francisco, 1916.
Oil on canvas, 24" x 30".
Photo of painting: Collection Concordia University–Portland.

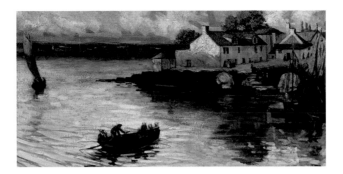

2
Elmer before Berta

Elmer Stanley Hader, born in Pajaro, California in 1889, was one of four children. With siblings Waldo, Carl, and Leota, the family moved to San Francisco in the early 1890s. Elmer would tell people that he grew up in "The City," attended school there, and worked part-time as a silversmith's apprentice. Then his world went up in flames. During the disastrous earthquake and fire of 1906, Elmer, as a bugler in the National Guard, was among those recruited to dash into stores as firemen shot water in over their heads, to rescue all of the food items they could. Elmer had anticipated that he'd finish high school and then attend the California School of Design. But because of the earthquake and fire there was no California School of Design.

After the San Francisco tragedy, he traveled to the Sacramento area and worked as a surveyor's assistant along the American River. A few months later, he returned to San Francisco and took a job as a fireman for the railroad that employed his father, Henry Hader. Henry was an engineer on the SF Beltline, a shuttle railroad that worked along the docks. Elmer saved his money and as soon as he heard that the California School of Design had been rebuilt, he used the $75 he'd saved and enrolled. He never had to come up with tuition money again as scholarships kept coming his way.

No one was surprised when Elmer won the scholarships. Shortly after his birth, his mother, Lena, had predicted that he was "going to be an artist and that he was going to travel much and far." [45] Like Berta, he too had a vivid memory of his third grade teacher enlisting him as the class artist. He loved to sketch and paint. He began to make a name for himself at the California School of Design and was proud to win a tuition scholarship to Académie Julian in Paris. A classmate of his, Ed Holl, also won a scholarship. Elmer was a confident, resourceful young man; handsome, determined, dramatic, and adventurous. He and Ed decided that they should be able to put their creative minds together to devise a money-making plan to cover the cost of getting to Paris and the cost of room and board once they arrived. Perhaps they could build a quick nest egg by becoming performers.

Holl and Hader formed the Stanley-Edwards troupe and developed a vaudeville act in 1909, which they called "The American Dream," and booked with the Sullivan Concert Circuit. They would don white leotards, powder, plaster, and paint, and then assume and hold the positions of world-famous statues. They joined the White Rats Actors Union, toured the country, and were well received.

They expanded the act by enlisting the help of two young women and changed the name of the show to "Visions in Marble." Audiences loved the performances, though the two girls stopped loving them the night that Elmer neglected an important step in preparation. After the show, there was great difficulty in removing the plaster of Paris. Apparently, as tears streamed down across rigid white cheeks, the girls decided to leave the troupe. Holl and Hader then created a different routine that would again involve only the two of them, "A-Sketch-A-Minute." People in the audience would call out a subject and within a minute Ed or Elmer would draw it. Elmer's family saw the months slipping by and decided they wanted to help him follow his artistic path. His parents and siblings each contributed money to get him to Paris to begin his studies there. The vaudeville days came to an end.

Elmer and Ed arrived in Paris in 1911. At the prestigious Académie Julian, Elmer studied the human form, portraiture, still life, and landscape in the impressionistic style which, though still considered avant-garde in America, was well established in Europe. Surrounded by exciting, inspiring instructors and fellow students, Elmer was an apt pupil. He was thrilled when one of his paintings, *Winter, Little Falls, New York,* was chosen to be included in the 1914 spring salon of the Société des Artistes Français. He'd been enamored with the beauty of that spot when he visited there in 1911 and had done a small plein air painting of the scene. It served as his reference for the larger painting in 1913.

His studies came to an end with the threat of the war. He made plans to head home but decided first to have a brief stay in England. He secured a permit to be a street artist and honed his Paris-acquired skills by painting English gardens. He returned to the United States in late 1914. Before he left Paris one of his instructors gave him the following advice: *"Il faut étonner le monde!"* (You must astonish the world!) and *"Il faut faire vos relations."* (You must make the right contacts.)[10] He moved into his parents' home in the Mission District of San Francisco and converted the attic into his art studio. Elmer announced that his plan was to become the most famous artist in the United States, or perhaps the world. He hauled his paints and easel around San Francisco painting daily, but he was mostly drawn to Telegraph Hill to paint scenes of the bay. Lugging his supplies with him each day was tiring and an acquaintance suggested that he ask the nice young lady who lived in the house built of old signage timbers if he mightn't store his paints and easel there each day. He knocked on the door, it opened, and there stood Berta Hoerner.

Elmer's vaudeville business card, with sketches from his vaudeville scrapbook.
Card: Collection Concordia University–Portland.; Sketches: Collection U of O, AX441 (Addenda), Box 7, Vaudeville Scrapbook.

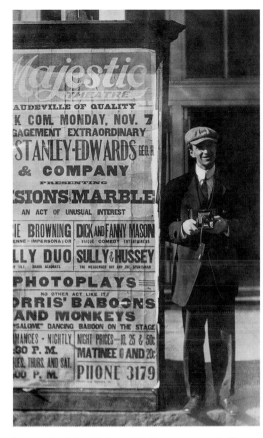

Poster advertising Hader and Holl's statuary vaudeville act.
Collection U of O, AX441 (Addenda), Box 7, Vaudeville
Scrapbook.

Portrait of Elmer Hader during his vaudeville years.
Collection U of O, AX441 (Addenda), Box 7, Vaudeville Scrapbook.

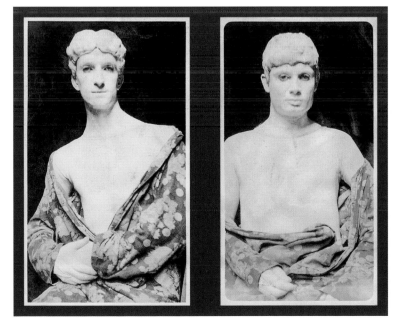

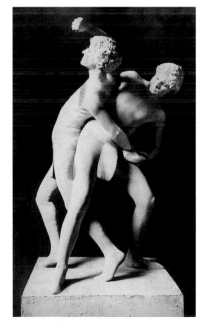

Elmer Hader and Ed Holl in costume for their statuary vaudeville act, *The American Dream*.
Collection U of O, AX441 (Addenda), Box 7, Vaudeville Scrapbook.

Elmer and Ed posing for their vaudeville act.
Collection U of O, AX441 (Addenda), Box 7,
Vaudeville Scrapbook.

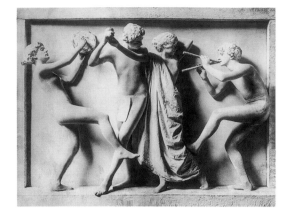

The Stanley-Edwards Company quartet performing their statuary vaudeville act, *Visions in Marble*.
Collection U of O, AX441 (Addenda), Box 7, Vaudeville Scrapbook.

Visions in Marble performance by Elmer and Ed's Stanley Edwards vaudeville troupe.
Collection U of O, AX441 (Addenda), Box 7, Vaudeville Scrapbook.

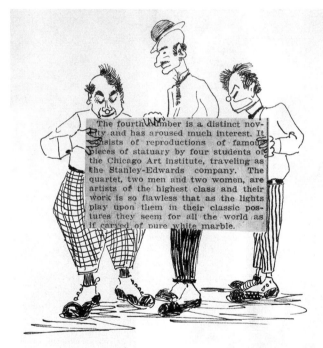

Hand-drawn cartoon with newspaper clipping praising Hader and Holl's *Visions in Marble* vaudeville act.
Pen and ink.
Collection U of O, AX441 (Addenda), Box 7, Vaudeville Scrapbook.

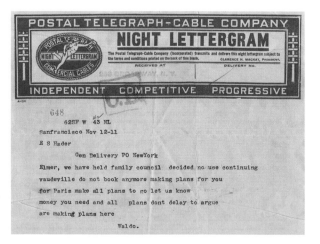

Telegram from Elmer's family offering financial assistance for his trip to Paris to study art at Académie Julian.
Collection U of O, AX441, Box 3, Folder S.

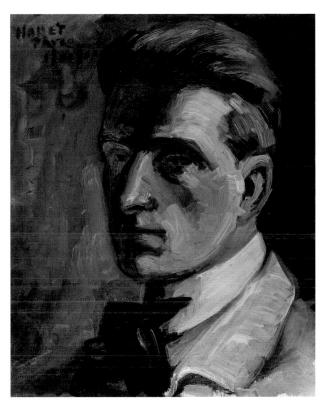

Detail from *Self-portrait* showing Elmer's early painting style.

Self-portrait
Elmer Stanley Hader, Paris, 1913.
Oil on canvas, 16" x 13".
Photo of painting: Collection Concordia University–Portland.

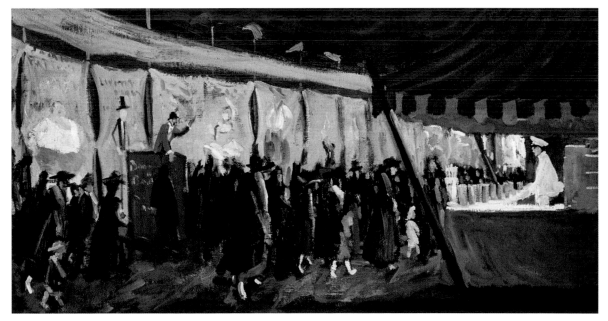

Corner of Place de Theatre, Carnival
Elmer Stanley Hader, Paris, c. 1913.
Oil on canvas, 20" x 38".
Photo of painting: Collection Concordia University–Portland.

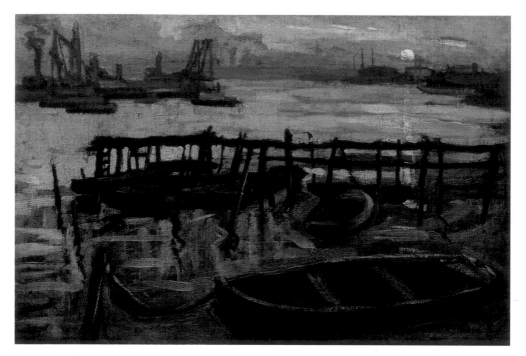

Sunset on the Thames
Elmer Stanley Hader, London, 1912.
Oil on canvas, 12" x 18".
Photo of painting: Collection Concordia University–Portland.

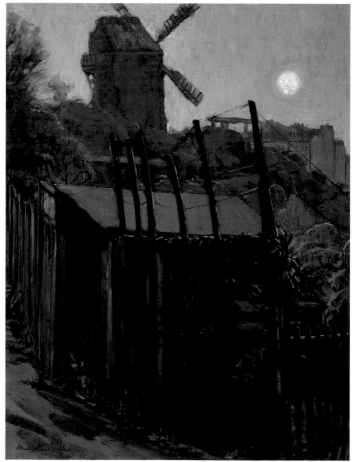

Windmill, Paris
Elmer Stanley Hader, Paris, 1912.
Oil on canvas, 31" x 23".
Photo of painting: Collection
Concordia University–Portland.

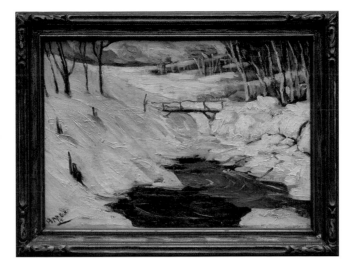

Preliminary study for *Little Falls, New York,* painted in New York in 1911.
Elmer Stanley Hader.
Oil on canvas, 10" x 15".
Private collection.

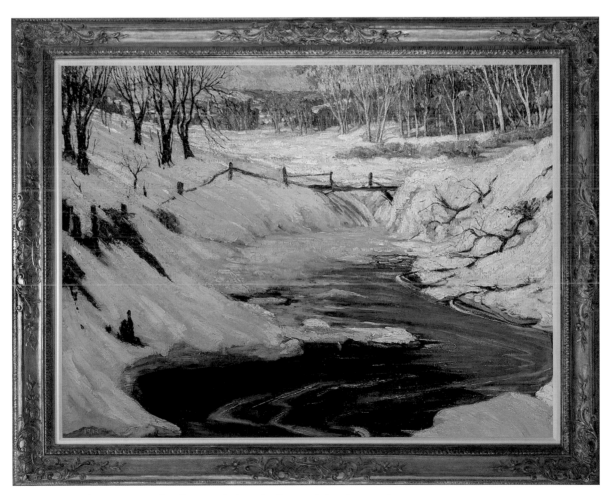

Elmer Stanley Hader's painting, *Little Falls, New York,* painted in Paris in 1913 and accepted
into the prestigious Société des Artistes Français annual exhibition in Paris, 1914.
Oil on canvas, 38" x 50".
Photo of painting: Private collection, courtesy Russell Tether Fine Art.

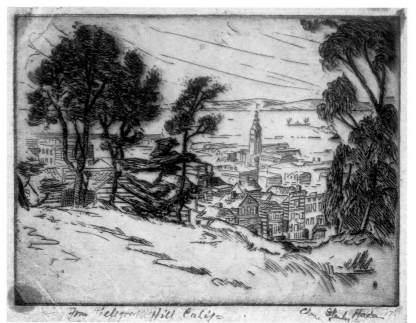

From Telegraph Hill, California
Elmer Stanley Hader,
San Francisco, 1917.
Etching, 6½″ x 8½″.
Private collection.

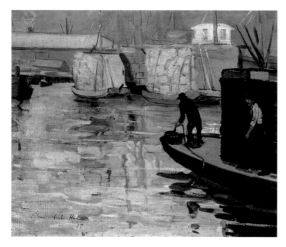

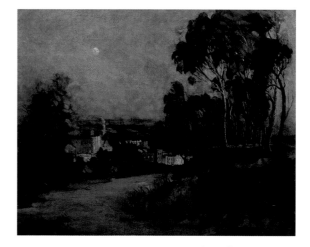

The Hay Barge
Elmer Stanley Hader,
San Francisco, 1917.
Oil on canvas, 16″ x 18″.
Photo of painting:
Collection Concordia
University–Portland.

Dawn from Telegraph
Elmer Stanley Hader,
San Francisco, 1917.
Oil on canvas, 26″ x 32″.
Photo of painting:
Collection Concordia
University–Portland.

San Francisco Harbor
Elmer Stanley Hader,
San Francisco, 1917.
Oil on canvas, 24″ x 32″.
Photo of painting:
Collection Concordia
University–Portland.

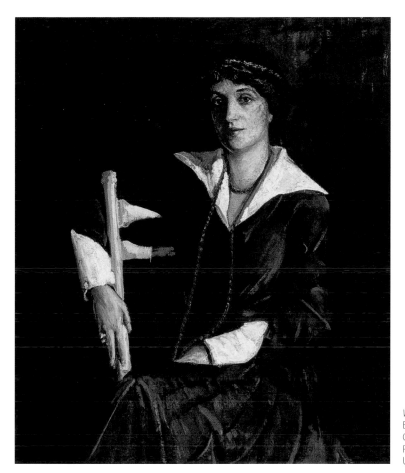

Woman in Black and White
Elmer Stanley Hader, Paris (?), 1913.
Oil on canvas, 38" x 32".
Photo of painting: Collection Concordia
University–Portland.

Old Monte of Telegraph Hill
Elmer Stanley Hader, San Francisco, 1916.
Oil on canvas, 18" x 13½".
Photo of painting: Collection Concordia University–Portland.

Breton Woman and Child
Elmer Stanley Hader, France, c. 1913.
Oil on canvas, 30" x 28".
Photo of painting: Collection Concordia University–Portland.

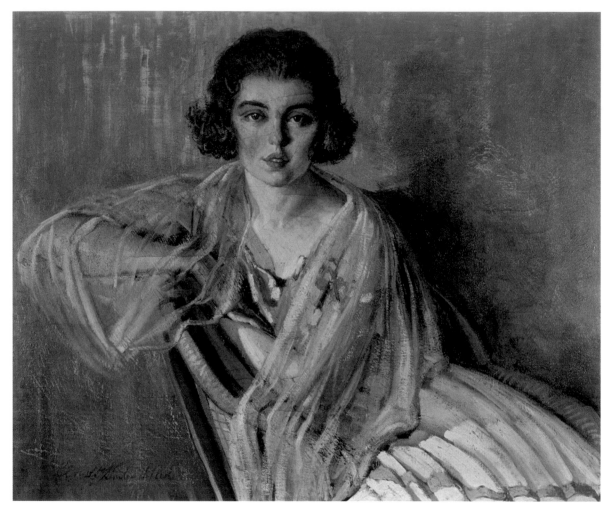

Miss B. H. (Elmer's award-winning portrait of Berta Hoerner)
Elmer Stanley Hader, San Francisco, 1917.
Oil on canvas, 32½" x 38".
Photo of painting: Collection Concordia University–Portland.

3
Courtship Years

Berta had created a small studio in her Telegraph Hill residence that attracted many of the local artists. They gathered, talked, shared ideas, and inspired one another. Elmer fit right in. Berta and Elmer formed a friendship from their first encounter, a relationship of love and mutual respect that never waned.

Berta continued to work for the newspaper and to paint and sell her lovely miniature portraits on ivory. These tiny wonders received high praise from many, but it was her artistic mother that Berta relied upon for honest critiques. Adelaide, though far away, did continue to provide guidance and suggestions regarding Berta's art. After receiving a miniature from Berta, she wrote to compliment her work, but told her she was charging too much money as her technique was not yet fully developed. [14] Gazing at her miniatures today, one can't help but think that this advice must have spurred her on to greater achievement, and indeed her technique did fully develop.

Elmer's brushes were rarely at rest. He painted scenes of San Francisco Bay, Telegraph Hill, and the heart of the city. He accepted commissions to do portraiture work in oils. He painted a portrait of Berta, which would grace the walls of their home for the rest of their lives. Elmer's art did receive recognition: his pieces were exhibited in one-man shows at both The Palace of Fine Arts in San Francisco and across the bay at the Oakland Museum of Art in Oakland, California. In both shows he received high praise, but there were some critics who didn't like his chosen subjects. San Franciscans were proud of the progress in their recovery from the earthquake and fire of 1906, and many of Elmer's paintings depicted shacks and shanties in a poorer section of the city. [48] In the 1918 show at the Palace of Fine Arts, Elmer did win a prestigious prize for Berta's portrait. He seemed well on his way to becoming the "most famous artist in the world!"

Louise E. Taber, a contemporary San Francisco art critic, said of Elmer's Palace of Fine Arts show, "The keynote of his success is sincerity. His love goes towards that which is humble and commonplace and into this he reads the ideals of a loftier reality. [Jean-François] Millet [prominent French artist in the nineteenth century] has written that 'it is the treating of the commonplace with the feeling of the sublime that gives to art its true power.' We remember this when seeing the manner in which Mr. Hader has handled subjects." [69]

When the United States entered World War I, Elmer was drafted into service in the United States Army. In December, 1917, he was sent to basic training, conveniently at the Presidio in San Francisco. It was decided that because he spoke French and had artistic abilities, he should serve in the camouflage corps and was eventually sent to France. Meanwhile, Bessie Beatty had returned from Russia and had become the editor of *McCall's Magazine*. She asked Berta to move to New York to do fashion design for *McCall's*. Berta was missing Elmer but was writing to him regularly. She decided she could do both of those things just as well on the East Coast. Berta packed up and moved across the country in the second half of 1918.

Berta moved in with Bessie Beatty for a short time. Rose Wilder Lane had been in Europe and when she returned to the United States she, too, came to New York. Rose and Berta found a place and were living under the same roof again. They rented a three-story house on Jones Street, which had no heat, but they had survived the cold of San Francisco and so were sure they would do just fine.[50] Apparently, they had very little furniture as well. They had springs for a bed but no mattress. They would later tell stories of waking up, having piled all of their clothes upon themselves for warmth, looking like waffles.

Many stories could also be told about all the visitors to the Jones Street house. Another writer, Eve Chappel, moved to New York and stayed with them for a bit. In fact, the Greenwich Village house became headquarters for many of Berta's and Rose's transported San Francisco friends. But the visitors weren't only from California. Rose had met interesting people in her European travels and at one point Prince Zog of Albania (who was in the United States for eye surgery) came to visit and Berta painted his portrait in miniature.[3]

Berta approached Bessie with the idea of a monthly children's page for *McCall's*.[18] The idea turned into reality as the first one appeared in the February issue of 1919. It was entitled "Here Are Valentines," an illustration in which Berta's skills at layout and design are evident, as is the delicate touch that she acquired doing her miniature paintings. This monthly children's feature exhibited a wonderful blending of technical art skills, captivating images, and strength of graphic design. These pages were produced with the by-line of Barbara Hale. Presumably Berta chose the name Barbara Hale as a pseudonym because people often called her Bertha rather than Berta and because folks seemed to have difficulty knowing how to pronounce her last name, Hoerner. It is assumed she took the nom de plume to achieve simplicity in name recognition and also perhaps to make a distinction between her juvenile creations and the other artwork she was doing.

Elmer's letters to Berta spoke of lovely sunsets and vistas and of his thoughts and hopes once he returned home. Nearly every letter started out, "Dear Curly Top," because of Berta's naturally curly hair. A letter written in December of 1917 (possibly before Elmer's pre-deployment leave) began, "Bon Jour Fuzzy Top, Another day has passed and you are 24 hours nearer to me."[37] Berta saved all of Elmer's illustrated letters. Her letters to Elmer were lost over time, but they were undoubtedly illustrated as well.

Elmer returned from the war in February of 1919. Rose and Berta thought it made perfect sense to have Elmer move into the unused space on the top floor at the Jones Street house. He set up a studio there. He and Berta began making plans to marry and to start their lives together as Mr. and Mrs. Elmer Stanley Hader.

One of Berta's miniature portraits.
Shown actual size (2⅝" x 3½").
Gouache on thin slab of ivory.
Collection U of O, AX441 (Addenda),
Box 5, Folder: Miniatures, Item 12.

Header for *McCall's Magazine* feature stories (August, 1919) created by Berta Hoerner.
Printed 4½" wide (two column) in the magazine. Berta also created abbreviated (one-column) and extended (three-column) versions.
Pen and ink on illustration board (scanned from original art board).
Collection Concordia University–Portland.

Fashion illustrations were typically done by freelance artists who were not credited. These illustrations are scanned from *McCall's Magazine*, August, 1919, during the time when Berta was doing fashion illustration for the magazine. Comparing the style of these drawings to that of Berta's children's pages and other magazine illustrations, it seems safe to assume that her drawings would have looked much like these, and indeed these could be hers.

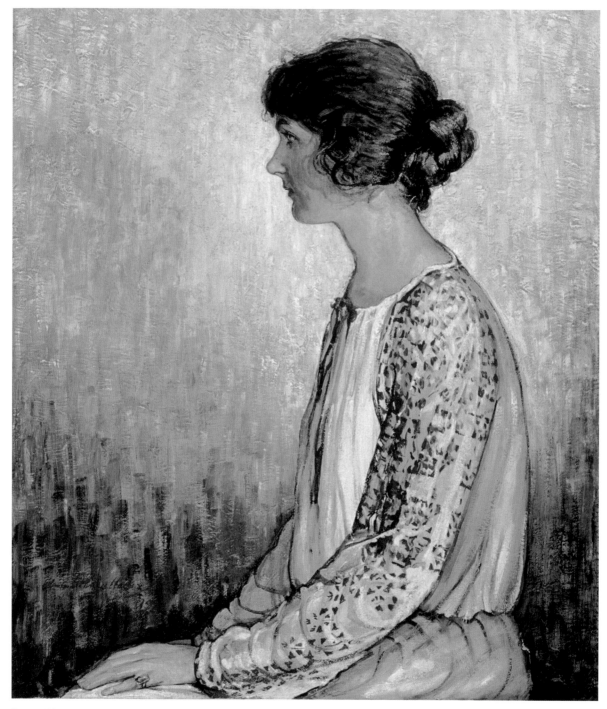

Frances Adams
Elmer Stanley Hader, Nyack, New York, 1919.
Oil on canvas, 36" x 30".
Photo of painting: Collection Concordia University–Portland.

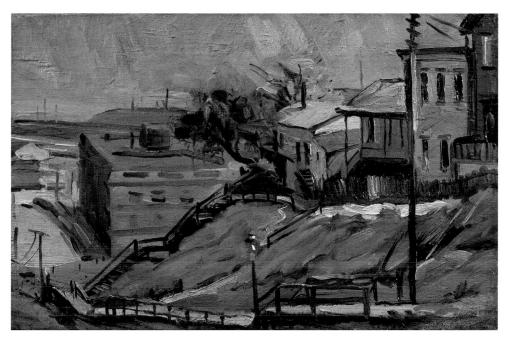

Street of a Thousand Stairs
Elmer Stanley Hader, San Francisco, 1917.
Oil on canvas, 12" x 18"
Photo of painting: Collection Concordia University–Portland.

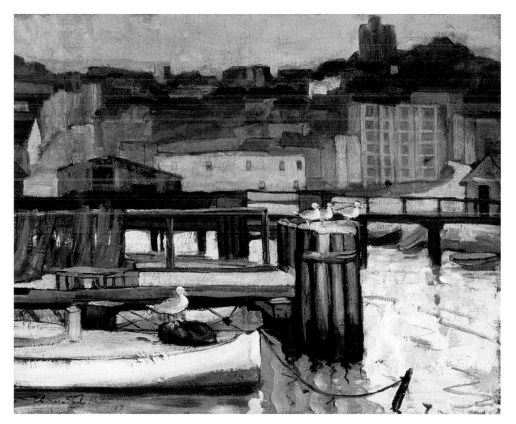

Sunny Afternoon, Fisherman's Wharf
Elmer Stanley Hader, San Francisco, 1917.
Oil on canvas, 15" x 18".
Photo of painting: Collection Concordia University–Portland.

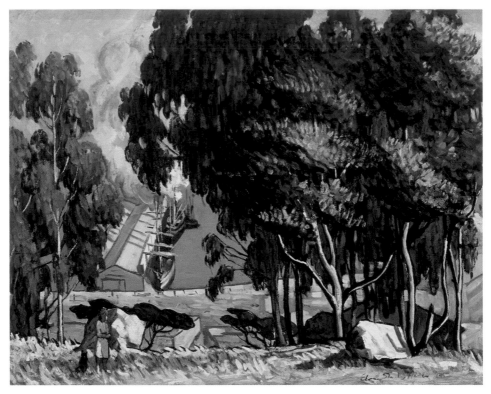

Through the Trees: Landscape and Docks
Elmer Stanley Hader, San Francisco, 1917.
Oil on canvas, 24" x 30".
Photo of painting: Collection Concordia University–Portland.

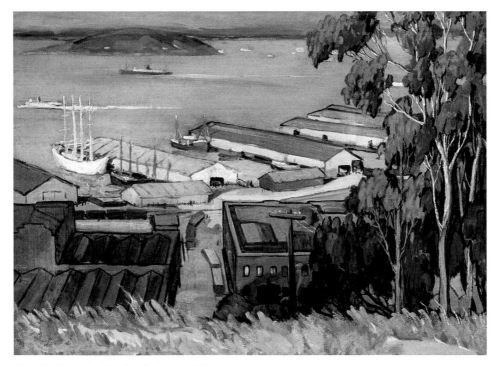

Above the Docks: San Francisco Bay from the Hill
Elmer Stanley Hader, San Francisco, 1917.
Oil on canvas, 22" x 30".
Photo of painting: Collection Concordia University–Portland.

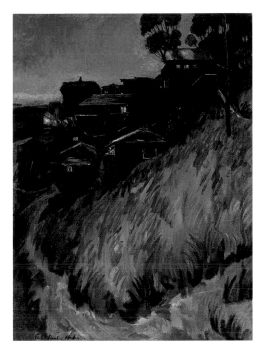

The Hillside, Telegraph Hill (Nocturne)
Elmer Stanley Hader, San Francisco, 1917. Oil on canvas, 38" x 28". Photo of painting: Collection Concordia University–Portland.

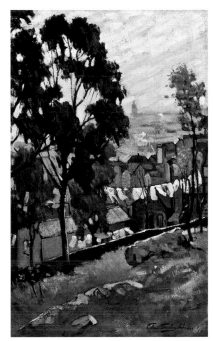

Spring Morning, Telegraph Hill
Elmer Stanley Hader, San Francisco, 1917. Oil on canvas, 36" x 22". Photo of painting: Collection Concordia University–Portland.

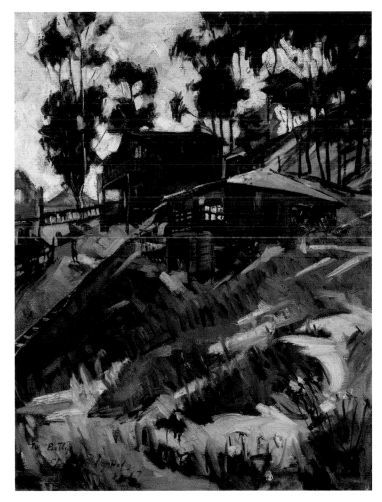

The Studios, Telegraph Hill (where Berta lived) Elmer Stanley Hader, San Francisco, 1917. Oil on canvas, 24" x 18". Photo of painting: Collection Concordia University–Portland.

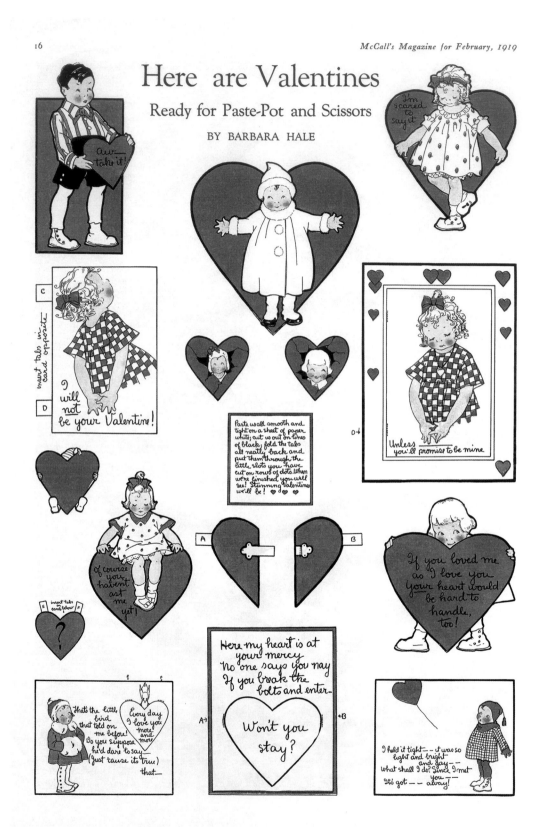

16 · McCall's Magazine for February, 1919

Here are Valentines
Ready for Paste-Pot and Scissors
BY BARBARA HALE

"Here Are Valentines," Berta's first children's page for *McCall's Magazine,* February, 1919.
Berta Hoerner, under pseudonym Barbara Hale.
Pen and ink with watercolor and gouache (scanned from magazine tearsheet).

Details from original art board for "I Sniffed a Jolly Woodsy Smell as I Came in Today" (Christmas ornaments to cut out and assemble), children's page for *McCall's Magazine*, December, 1920. Berta Hoerner, under pseudonym Barbara Hale. Pen and ink with watercolor (scanned from original art board). Collection Concordia University–Portland.

"Baskets Gay for Flowers of May," children's page for *McCall's Magazine*, May, 1920. Berta Hoerner, under pseudonym Barbara Hale. Pen and ink with watercolor (scanned from original art board). Collection Concordia University–Portland.

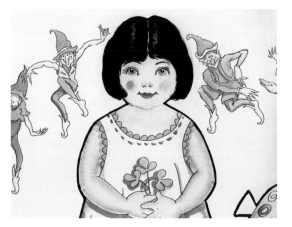

Detail from original art board for "An Irish Coleen With Her Irish Pig," Berta's children's page for *McCall's Magazine*, March, 1920. Berta Hoerner, under pseudonym Barbara Hale. Pen and ink with watercolor (scanned from original art board). Collection Concordia University–Portland.

Detail from scan of original art board for "Polykins Pudge Says 'Googlety-goo,' That's Baby Talk for 'Good Morning to You,'" Berta's fourth children's page for *McCall's Magazine*, July, 1919. Berta Hoerner, under pseudonym Barbara Hale. Pen and ink with watercolor (scanned from original art board). Collection Concordia University–Portland.

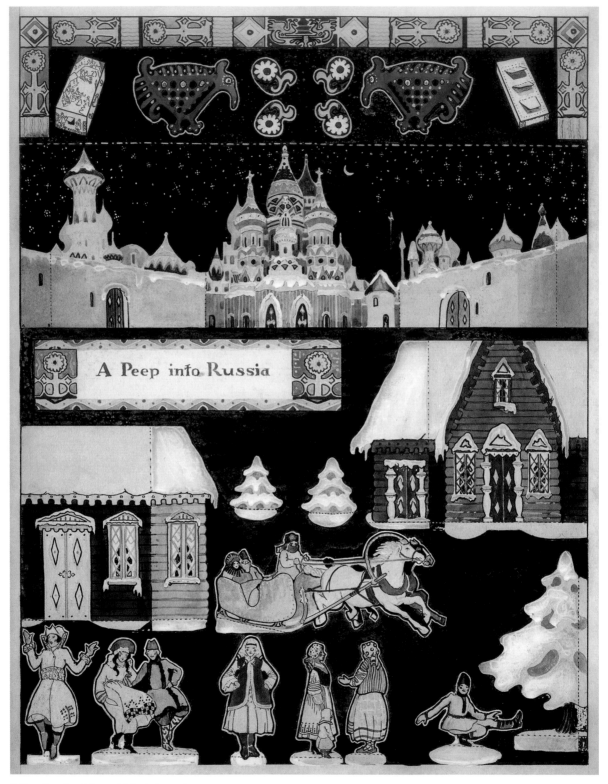

"A Peep into Russia," unpublished, date unknown.
Probably prepared as a prototype for *Pictorial Review* in 1925.
Berta and Elmer Hader.
Pen and ink, watercolor and gouache on illustration board (scanned from original art board).
Collection Concordia University–Portland.

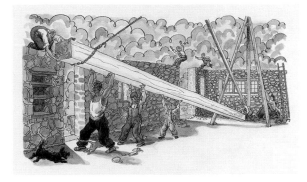

4
Early Years of Marriage

Berta and Elmer decided not to have a big wedding and simply asked a few friends to gather for their ceremony and party at Bessie Beatty's apartment on July 14, 1919. Berta's practical nature tended to avoid anything unduly fancy, and she had just planned to wear a skirt and blouse she already owned. Her friends objected that this would never do, so they sewed a special dress for her, completing it just minutes before she said, "I do." Once married, Mr. and Mrs. Hader decided they needed to find a place to live that could accommodate visits from their friends and would provide room for their art and space for the children they wanted to have.

They took many day trips venturing farther and farther out of the city until they found the perfect place to rent: Lyall Cottage in Grand-View-on-Hudson. The rent was $25 per month. The lay of the land reminded them of Telegraph Hill, and the Hudson was so wide at that point that it nearly looked like a bay. It was 25 miles north of New York City, a short ferry ride and train ride away from the source of their work.

Lyall Cottage had been a hotel. The Haders were happy to rent it for many reasons, but a major one was that it would easily accommodate their many and frequent guests. The pattern established in San Francisco, and continued in Greenwich Village, continued still. The Haders loved their friends and wanted them to be actively involved in their lives. And the friends loved the Haders. One year, for a Christmas present, Katherine Anne Porter coordinated the purchase and delivery of a present. Some distracted Berta and Elmer while others smuggled a washing machine into their home. The Haders were absolutely delighted and totally surprised. Berta cried. Then she wiped her tears and declared she was ready to name the machine. It was going to be called Abraham Lincoln—because it would free the slaves.

The newlyweds developed their pattern for living and working, a balance (if not schedule) they were to maintain the rest of their lives. They traveled to the city on Thursdays to seek art jobs. On Fridays, they prepared for friends to arrive for the weekend. Saturdays and Sundays, their home was full of friends and laughter. On Mondays, they took walks and looked for the right piece of land to buy and build their home. On very productive Tuesdays and Wednesdays, they did artwork. On Thursdays, they delivered the work and got new assignments. [6]

Berta and Elmer began producing art for magazines, including *Asia, Century, Metropolitan, Good Housekeeping, McCall's, Pictorial Review,* and *The Christian Science Monitor.* Bessie Beatty, as editor at *McCall's,* encouraged them and facilitated connections and suitable assignments for them. They created cover art, illustrations for stories, paper dolls, and action toys. Their large original art boards were beautifully designed on the page and carefully rendered in gouache and watercolor or delicate strokes of pen and ink. Both of their art trainings undoubtedly resulted in these beautiful designs. Elmer had a talent for developing character and his sense of humor shines through in their artwork. Berta's steady hand and eye for detail are also universally evident.

Their efforts to find available property were a bit frustrating, but they finally realized that an available parcel deemed unbuildable by the locals could accommodate a lovely home. Berta and Elmer's San Francisco days taught them that wonderful homes could be built on steep hillsides. They had saved enough money to afford two of the four acres, especially since the owner said she would accept a painting of herself, done by Elmer, as partial payment. Bessie Beatty loaned them the money for the other two acres. The Hader cronies were enthusiastic and happy for them. They believed that Elmer and Berta could build their own home because Elmer was always ready to be a handyman to everyone. Berta had a reputation of never shying away from work. But little did those friends know that Berta and Elmer would be turning weekend fun parties into weekend work parties and all would help to build that home.

Home planning, land seeking, art jobs, and entertaining filled up the Hader days. On March 8, 1921, a new addition to their home changed their lives. Hamilton Hader, a fine healthy boy blessed with a sunny disposition, was born. It was a time of extreme happiness, but also of fear and worry, for it was a very difficult birth and Berta nearly died. The midwife who had intended to spend a week after the birth ended up staying for six weeks, until Berta's recovery was assured. Berta was told she would never be able to have another child. Dear friends suggested they spend a few months at their home in Maine so Berta could truly regain her strength. The family of three spent the summer of 1921 there. Berta healed, Elmer painted, and little "Hammie" thrived.

The Maine paintings were the cornerstone for an exhibit of Elmer's works shown in New York City in 1922. These works were still done in the impressionistic style Elmer had developed in California and Paris. Elmer's abilities to capture quality of light and contrast had not waned and his paintings were very well received. However, this New York exhibit turned out to be the final showing of his paintings during his lifetime.

Hammie had many showings of his artwork. He loved to draw, and his proud parents tacked his creations up for all to see. He was the only child in their circle of friends and was adored by all. Comments were made about the fact that he received so much attention and yet was not a spoiled child. His adoring parents worried when he fell sick shortly after his second birthday. Tragically, within just a few days of having fallen ill, little Hammie died from spinal meningitis on May 11, 1923. Devastated, Berta and Elmer retreated to Bessie Beatty's home in Maine where they stayed for several months to attempt to work through their profound grief and refresh their spirits. They must have resolved to make all the world's children their own through their books and artwork.

When they returned to New York they rededicated themselves to building their home and their illustration career.

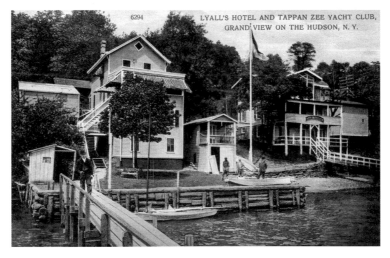

Lyall Hotel in Grand-View-on-Hudson, which became Berta and Elmer's first home in 1919.
(Photo shows the back side of the hotel, left, facing the Hudson River), 1900.
Collection The Nyack Library, Nyack, NY.

McCall's Magazine
June, 1920.

The Christian Science Monitor,
date unknown.
Note the similarity to Elmer's
painting, *The Concarneau
Fisherman* (Chapter 2 opener,
page 23).

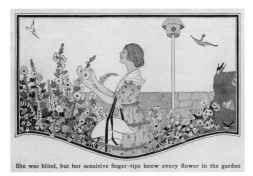

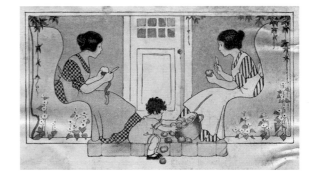

**Various magazine illustrations done by
Berta and Elmer in the early years of their career.**
(Tearsheets from Berta's scrapbook. Publication data for most images unavailable.)
Collection Concordia University–Portland.

"No one wants that old quarry and frog pond," said their friend. "No one could build a house on such a lot."

Illustration from the Haders' book *The Little Stone House,* which is based on their own land search and homebuilding experience (this page and facing page). Pen and ink with watercolor (scanned from original art board). Collection U of O, AX441, SC10.

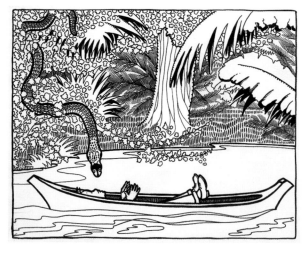

Illustration for *Asia* magazine, July, 1919. Elmer Stanley Hader. Pen and ink on illustration board (scanned from original art board). Collection Concordia University–Portland.

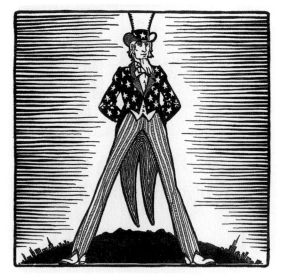

Uncle Sam, in "A Gallery of American Myths." Elmer Stanley Hader. Pen and ink (scanned from printed magazine page). *Century* magazine, April, 1924. Tearsheet: Collection Concordia University–Portland.

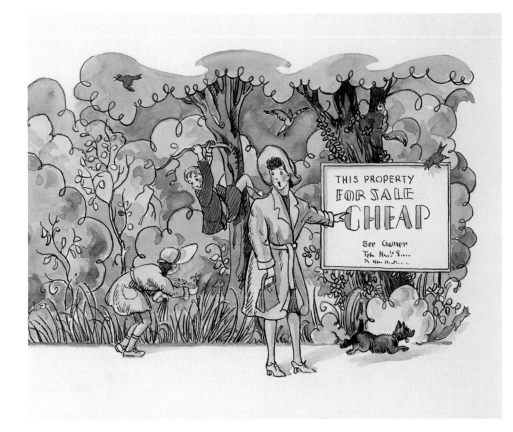

Illustration for *McCall's Magazine*.
(from Berta's scrapbook.)
Collection Concordia University–Portland.

Original artboard for illustration on the back
of *Metropolitan* magazine, Vol. XXIX, No. 10.
Berta and Elmer Hader.
Notice the testing of colors in the margin.
Collection Concordia University–Portland.

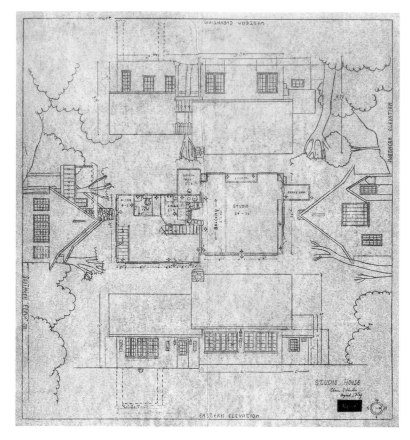

Elmer's hand-drawn elevation plans for The Little Stone House, circa 1922.
When cut apart and constructed, this made a three-dimensional model of the house.
Collection Concordia University–Portland.

Berta and Elmer's son Hamilton (Hammie) Hader, circa 1922.
Collection U of O, AX441 (Addenda), Box 7.

Berta with Hammie at Lyall Cottage, circa 1922.
Collection U of O, AX441 (Addenda), Box 7.

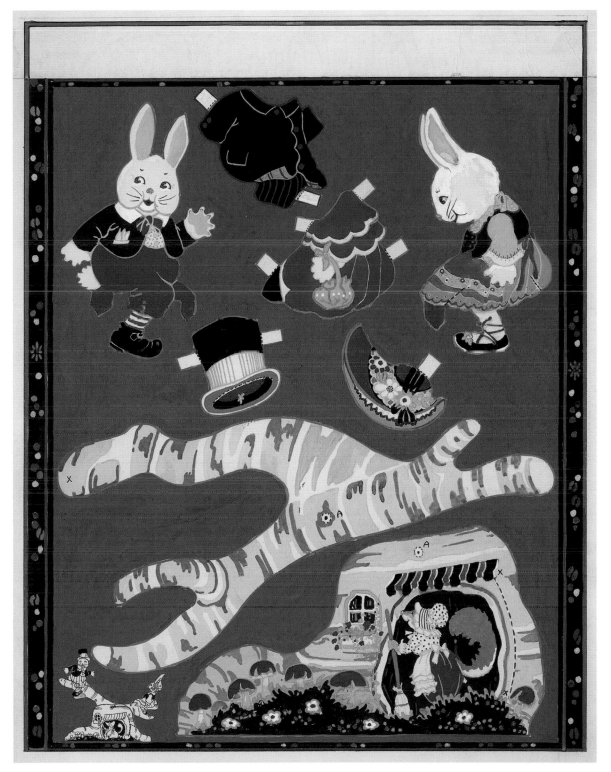

Untitled action toy, probably produced for *McCall's Magazine*, but not published, circa 1920.
Berta and Elmer Hader.
Gouache on illustration board (scanned from original art board).
Collection Concordia University–Portland.

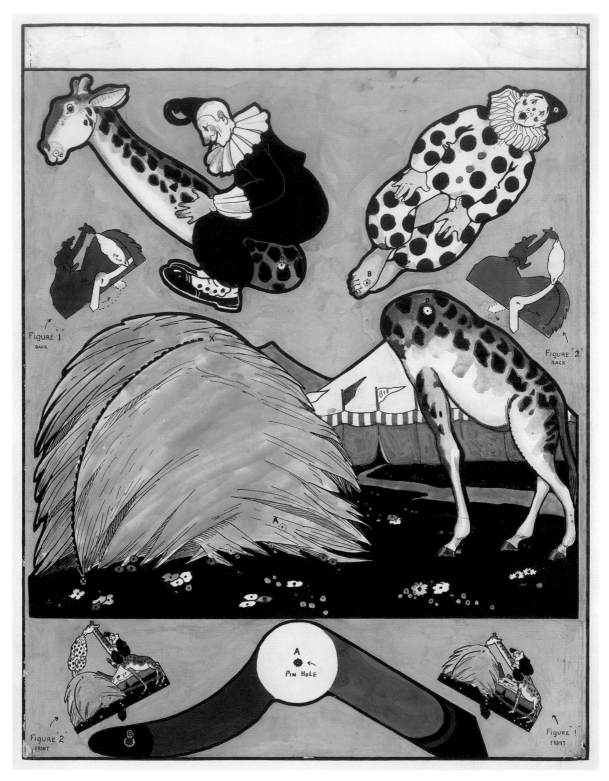

"Slim and Sli and Johnny Giraffe," action toy children's page for *McCall's Magazine*, February, 1924.
Berta and Elmer Hader.
Pen and ink, watercolor, and gouache on illustration board (scanned from original art board).
Private collection.

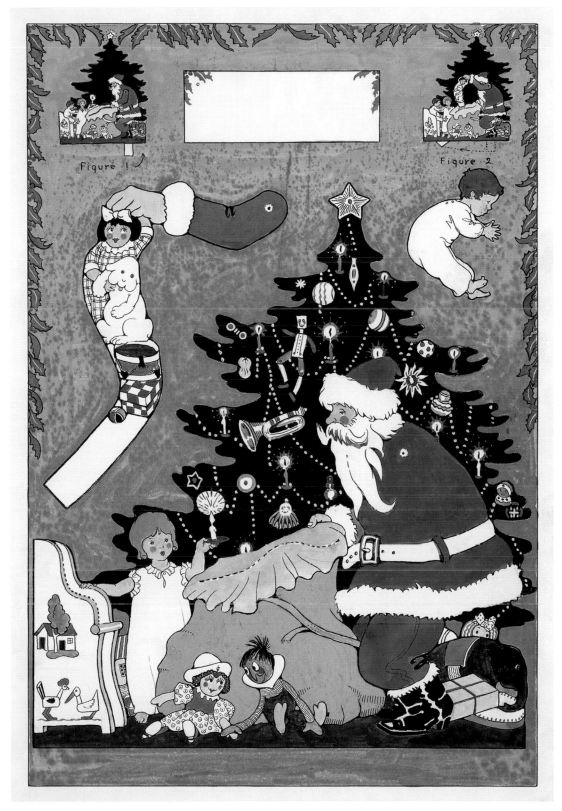

"Santa and His Sack," action toy children's page for *McCall's Magazine,* December, 1923.
Berta and Elmer Hader.
Pen and ink, watercolor, and gouache on illustration board (scanned from original art board).
Collection Concordia University–Portland.

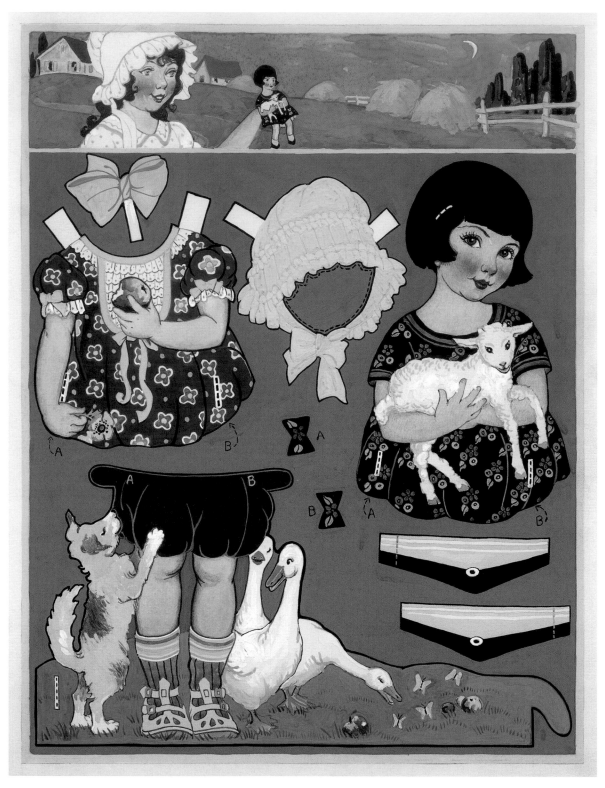

"Alice Spends July on Grandma's Farm" finger doll children's page for *Good Housekeeping* magazine, July, 1924.
Berta and Elmer Hader.
Watercolor and gouache (scanned from original art board).
Collection Concordia University–Portland.

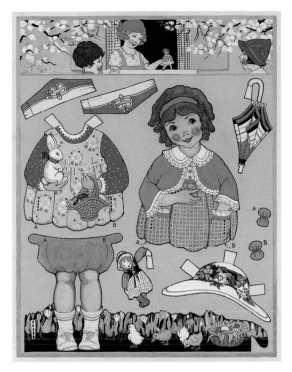

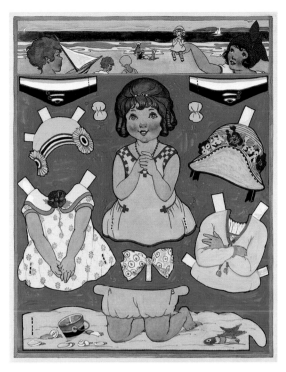

"Miriam Has a Happy Easter" finger doll children's page for
Good Housekeeping magazine, April, 1924.
Berta and Elmer Hader.
Watercolor and gouache (scanned from original art board).
Collection Concordia University–Portland.

"Betty Goes to the Beach in August" finger doll children's page
for *Good Housekeeping* magazine, August, 1924.
Berta and Elmer Hader.
Watercolor and gouache (scanned from original art board).
Collection Concordia University–Portland.

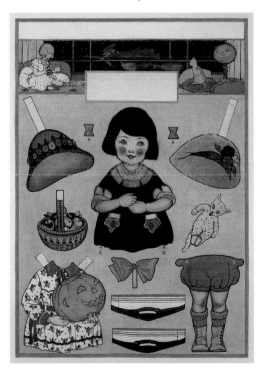

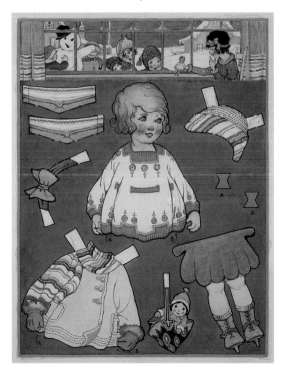

"Little Mary Jane" finger doll children's page for
Good Housekeeping magazine, October, 1923.
Berta and Elmer Hader.
Watercolor and gouache (scanned from original art board).
Collection Concordia University–Portland.

"Nancy and Her New Skates" finger doll children's page for
Good Housekeeping magazine, January, 1924.
Berta and Elmer Hader.
Watercolor and gouache (scanned from original art board).
Collection Concordia University–Portland.

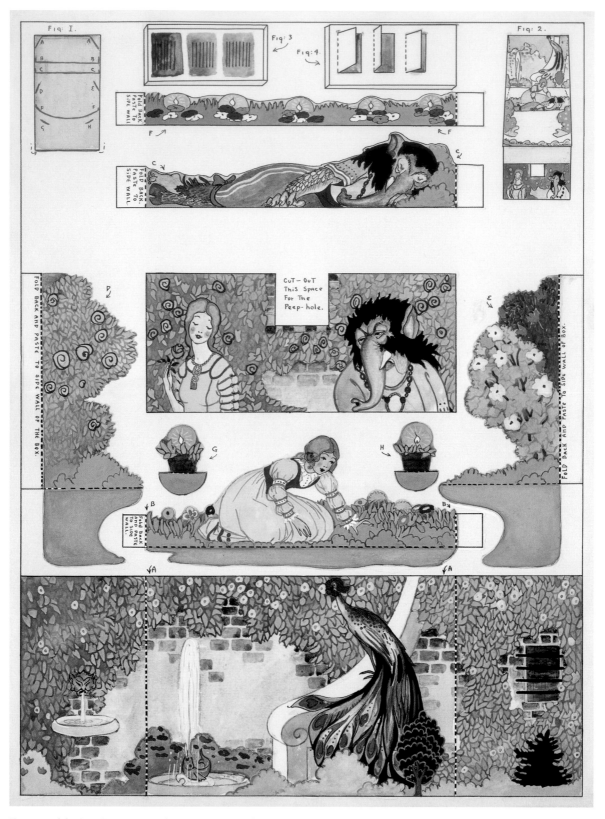

"Beauty and the Beast" Pin-a-Peep children's page, probably produced for *Pictorial Review* magazine, but not published, circa 1925.
Berta and Elmer Hader.
Watercolor on illustration board (scanned from original art board).
Collection Concordia University–Portland.

"Snow White" Pin-a-Peep children's page, *Pictorial Review* magazine, August, 1925.
Berta and Elmer Hader.
Pen and ink, watercolor, and gouache on illustration board (scanned from original art board).
Collection Concordia University–Portland.

Big Oak
Elmer Stanley Hader, West Point, Maine, 1921.
Oil on board, 18" x 24".
Photo of painting: Collection Concordia University–Portland.

Snow in Grand View
Elmer Stanley Hader, Rockland, New York, 1921.
Oil on board, 18" x 24".
Photo of painting: Collection Concordia University–Portland.

Fish House
Elmer Stanley Hader, West Point, Maine, 1921.
Oil on board, 18" x 24".
Photo of painting: Collection Concordia University–Portland.

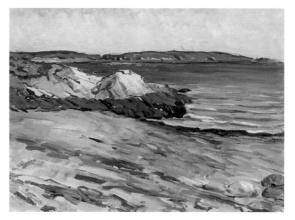

Last Rays
Elmer Stanley Hader, Haskell Beach, West Point, Maine, 1921.
Oil on board, 18" x 24".
Photo of painting: Collection Concordia University–Portland.

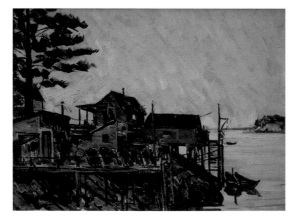

Lobster Shack at Sunrise
Elmer Stanley Hader, West Point, Maine, 1921.
Oil on board, 18" x 24".
Private collection.

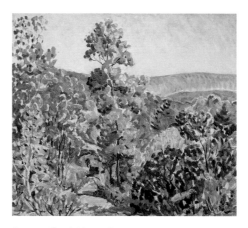

Autumn, South Mountain
Elmer Stanley Hader, Nyack, New York, 1923.
Oil on board, 18" x 20".
Photo of painting: Collection Concordia University–Portland.

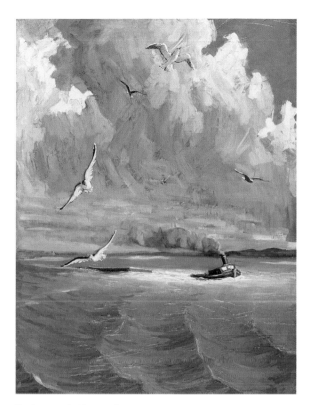

The Frozen Tappan Zee
Elmer Stanley Hader, New York, 1920.
Oil on board, 35" x 30".
Photo of painting: Collection Concordia University–Portland.

Tugboat on the Tappan Zee
Elmer Stanley Hader, New York, circa 1920.
Oil on canvas, 32" x 24".
Photo of painting: Collection Concordia University–Portland.

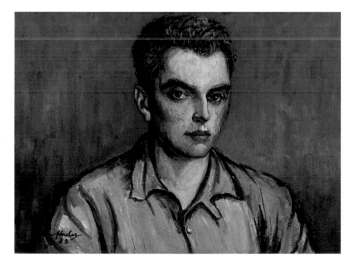

Portrait of Latrobe Carroll
Elmer Stanley Hader, New York, 1923.
Oil on board, 18" x 24".
Photo of painting: Collection Concordia University–Portland.

Portrait of Woman in Blue
Elmer Stanley Hader, New York, undated.
Oil on board, 24" x 18".
Photo of painting: Collection Concordia University–Portland.

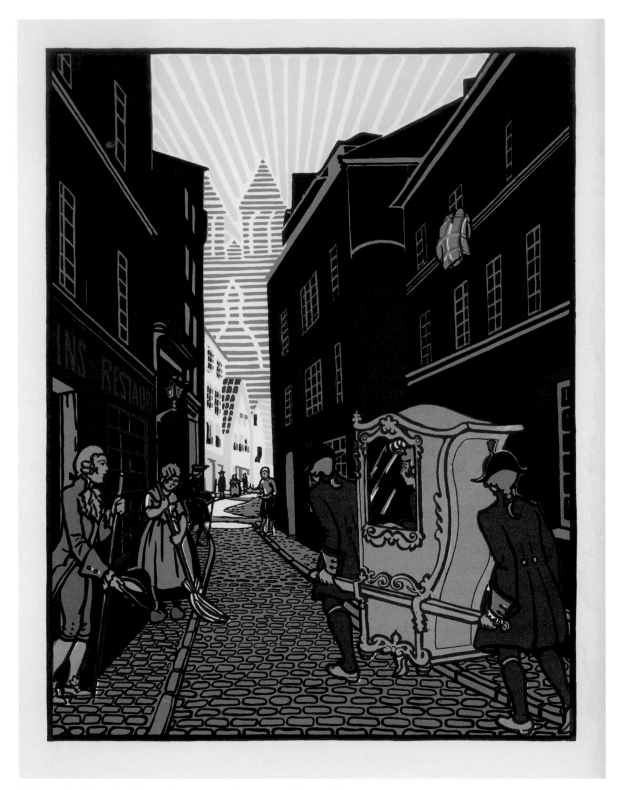

The Picture Book of Travel: The Story of Transportation, by Berta and Elmer Hader.
The Macmillan Company, 1928.
Black key plate with flat solid colors. Scanned from printed book. Private collection.

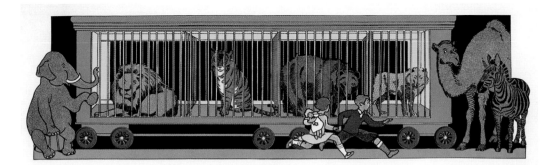

5
Early Book Days

Macmillan was the first publishing house to establish a children's department. They started it up in 1919 and chose Louise Seaman to take the helm. In 1927 she decided to find talented artists to illustrate the Happy Hour series of books she was envisioning. She decided a contest was called for. The tale she wanted illustrated was *The Ugly Duckling*. The Haders entered, and they were chosen. Louise said, "I held a competition for the first edition of the Happy Hour books. It was the dummy for *The Ugly Duckling*, done by the Haders, that stood out above all the rest of the artists' samples. It was so simple, so childish, so funny; the colors were so clear and bright; the ducks were well drawn; the layout was artistic without being 'arty'; the heavy black line meant a keyplate which would live, and a definite rhythm for the eye of the young person. All these qualities appeal to a wide public. I have only to throw one of these *Ugly Duckling* pictures on the screen from a lantern slide, to get a ripple of appreciation, chuckles all over the audience. I think it is a response to a human quality; it has little to do with appreciation of technique."[4]

The working knowledge of graphic design the Haders had and their awareness of proper preparation of art for the printing process were paying off. That preparation and training, mixed with the infusion of their personalities into their art, caused the "ripple of appreciation" which was to expand incredibly. They did the artwork for seven of the Happy Hour books. Their children's book career was well on its way. When Louise learned of Elmer's experience with trains, and knowing Berta's abilities to capture detail, she knew she'd found her illustrators for *The Wonderful Locomotive*, by Cornelia Meigs. The Rae Henkle Publishing Company produced *Donald in Numberland*, illustrated by the Haders. Berta and Elmer decided to write and illustrate *What'll You do When You Grow Up* and *The Picture Book of Travel*. Their friends jokingly called them the book-a-month Haders. They illustrated twenty-two books from 1929 through 1931, eight of which they also wrote.

For *The Wonderful Locomotive* the Haders submitted a third more illustrations than the publisher had anticipated and planned for. But Louise was smitten by the drawings. She said that Macmillan recounted its pennies, decided to go with all of the art, and soon discovered that every picture fitted perfectly into place.[4]

The Picture Book of Travel was the Haders' introduction to researching and dealing with a

more complicated layout and printing process. Black and five colors were to be used on one whole side of each signature, black and blue on the alternate side, and the vast subject of transportation up to the invention of machinery was to be compressed into a sixty-four-page picture book.[4] The result was dramatic and impressive.

The Haders found themselves blending art experiences from the past with current projects. Berta's fashion design expertise was evident in some of the book and magazine illustrations. Some scenes Elmer captured on canvas were replicated as backgrounds for book characters, such as in *Billy Butter,* with the Telegraph Hill backgrounds for the little goat. Their repertoire of experience was serving them well.

Berta and Elmer found that working together came completely naturally. Each piece of art for their children's books was created by the two of them. Their drawing boards were next to one another in their studio, both with their backs to the illuminating north light. As they passed pieces back and forth, phrases could be heard like, "This needs a little something, Dearie." And, "Say, could you Berta this up a bit?" Their ability to work in such harmony seemed to be so often beyond belief that Macmillan decided to publish a book about it. Berta and Elmer wrote *Working Together: The Inside Story of the Hader Books* in 1937. The mystery was solved: Berta and Elmer truly did work together.

Elmer was sometimes approached and asked to create art for dust jackets. In 1936, prominent novelist John Steinbeck was so taken with the *Billy Butter* illustrations that he and his publisher, Viking, arranged with Elmer to paint the cover art for some of his books. Elmer did the artwork for four of John Steinbeck's books: *The Long Valley, The Grapes of Wrath, East of Eden,* and *The Winter of Our Discontent.* Correspondence between Elmer and Viking chronicled the process for the creation of the art for *The Grapes of Wrath.* At Viking's request Elmer submitted six sketches. After receiving feedback, he drew three additional sketches. Then, with more input, he understood the elements that Viking was hoping to capture in the dust cover art and submitted two paintings. One of the paintings was enthusiastically embraced by Steinbeck and became *The Grapes of Wrath* cover art. It also became the most widely recognized, iconic image of the Dust Bowl migration of the 1930s. Elmer was paid $75 for that painting.[13] The original watercolor was sold at auction in 2001 for $63,250.

Readers of all ages seemed hungry for the written word. The children's book world was exploding. In 1933 Elmer wrote: "Attracted by the success of a few pioneers in the field, publisher after publisher added a juvenile department and brought out books for the young. The stimulation of competition tended to make for better books. One has only to compare the books now available, with those of ten or fifteen years ago, to mark the change. Not all were successful in catering to the taste of the young. And the reason is not at all obvious. Just what makes some popular and others unsuccessful is, as far as we are concerned, an enigma. It is the ambition of those who write, illustrate or publish in this particular field, to create something that will win its way to the child's heart. Children are loyal and once installed in their affections a book is due for a long life."[34]

In finding the way to children's hearts everyone was learning together. The Haders shared that when they took their *Mother Goose* drawings to Louise Seaman at Macmillan with the idea of putting them into a small book, Louise didn't know what to do with them. The Harper publishing house planned to take the book sometime later but had to send to Europe to get prices—and some advice. The book was eventually published in 1930 by Coward-McCann under the title of *Berta and Elmer Hader's Picture Book of Mother Goose,* and it was very well received. The ambitious number of 10,000 copies as a first run sold out quickly, and many more printings were run.

Even as details needed to be worked out, humor seemed to prevail in their communications.

In one response to editor Doris Patee, the Haders replied, "We are putting our giant intellects to work in an attempt to solve that problem."[28] Once when the art department confessed that they had lost the title page art for one of the books, the Haders responded that they had done up another one and were sending it but, "…perhaps you should hire an armored car to deliver it to the printer."[25] In another letter to Doris written in 1944 they said, "We appreciate your editorial talent no end and count on your taste and guidance to lead us in time, to that goal of goals, in the juvenile book world, the NOBEL prize."[28] Louise said, "The Haders cheer you by the funniest letters, neatly typed, and decorated with ridiculous pictures in bright colors. No other bills or thank-yous for checks or appointment notes ever carried so many laughs into a publisher's files."[4]

Another part of the learning process for the Haders was adjusting to changes in the printing world. New options were being presented as to how to prepare the art to meet the printer's needs and the publisher's budget. With the producing of *Green and Gold,* for example, Doris Patee wrote to the Haders in 1935 that the printer was suggesting a change from the way the art reproduction would be done, which would necessitate a preparation change by the Haders. Instead of black key drawings and color overlays, he proposed either a light black wash key with dummy drawings for color indications, or making all of the pictures in full color with no black outlines anywhere.[61] Another printer, Mr. Stringer of the Jersey City Printing Company, explained that the original proofs of *Mother Goose* were unacceptable because the lithographic plate filled in when it was on the press, which accounted for the thick appearance of the colors.[38] Everyone was learning.

The challenges got ironed out and the books were produced. Children were made happy. The Haders received letters of appreciation from children regularly as well as invitations to make presentations about specific books and about their career. The Haders enjoyed demonstrating art techniques in schools and the book sections within major department stores. Since they also often did readings in small bookshops and libraries, they created a portable drawing frame to use.[30] Often Berta would do much of the talking while Elmer was drawing, perhaps using his old vaudeville, sketch-a-minute techniques. The young audiences loved them. They were children's book authors and artists now.

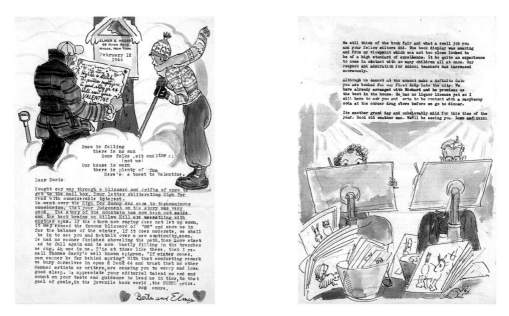

Illustrated letters from Berta and Elmer to editor Doris Patee. Scanned from originals.
Collection U of O, AX441, Box 1, Correspondence, Outgoing.

Illustrations from *Chicken Little and the Little Half Chick,* Happy Hour book illustrated by Berta and Elmer Hader.
The Macmillan Company, 1927.

The colors in all these illustrations were printed as flat solid colors, registered to the black lines (key plate). This resulted in much richer colors than the halftone printing used in most of the Haders' other books. (See Glossary for definitions of terms.)
All scanned from printed books. Private collection.

Illustrations from *The Ugly Duckling* by Hans Christian Andersen, the first Happy Hour edition illustrated by Berta and Elmer Hader.
The Macmillan Company, 1927.

Illustration from *Lion Cub: a Jungle Tale,* written by Hamilton Williamson and illustrated by Berta and Elmer Hader.
Doubleday, Doran & Co., 1931.

Illustration from *Donald in Numberland,* written by Jean Murdoch Peedie and illustrated by Berta and Elmer Hader.
Rae D. Henkle Company, 1927.

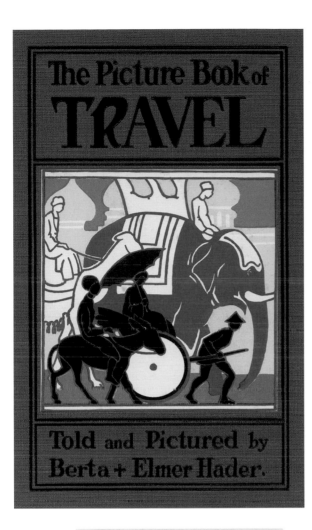

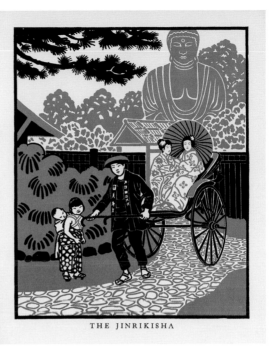

THE JINRIKISHA

Cover illustration (left) and interior illustration (above) from
The Picture Book of Travel: The Story of Transportation, by Berta
and Elmer Hader.
The Macmillan Company, 1928.
Scanned from printed book. Private collection.
The Haders designed many of their book covers, even hand-
lettering the titles (left), and, with expert graphic design, they
could make a two-color illustration (above) as lively and
dramatic as if it were full-color.

Illustrations from *What'll You Do When You Grow Up?* by Berta and Elmer Hader.
Longman's, Green and Co., 1929. Scanned from printed book. Private collection.
The rich colors in these early book illustrations were printed as flat solid colors, with the black lines
(key plate, to which the colors were registered in printing) providing shading and dimension.

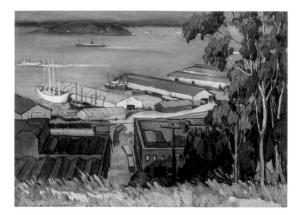

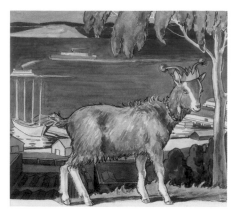

Elmer's Telegraph Hill painting (left), used as reference for the background of the illustration from *Billy Butter,* by Berta and Elmer Hader (right). The Macmillan Company, 1936. Photo of painting: Collection Concordia University–Portland. Illustration scanned from original art board (watercolor on illustration board). Collection U of O, AX441, SC 4.

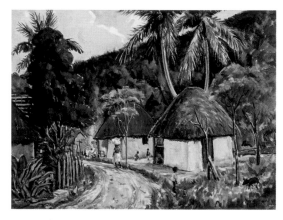

Elmer's painting from Haiti (left), used as reference for the illustration from *Jamaica Johnny,* by Berta and Elmer Hader (right). The Macmillan Company, 1935. Photo of painting: Collection Concordia University–Portland. Illustration scanned from printed book. Private collection.

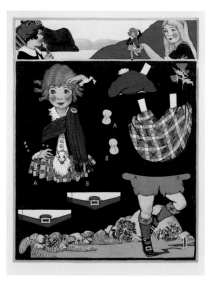

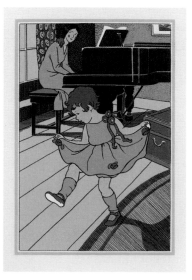

"Bonnie Bessie Lives in Scotland,"
Good Housekeeping magazine, November, 1924.
Watercolor and gouache on illustration board.
Scanned from original art board.
Collection Concordia University–Portland.

Illustration from *What'll You Do When You Grow Up?* by Berta and Elmer Hader.
Longman's, Green and Co., 1929.
Scanned from printed book. Private collection.
Note the similarity in style to the earlier magazine illustration (left).

"Go it, 44!" shouted Peter.

"How did you do it? Was it magic?"

Pen and ink illustrations from *The Wonderful Locomotive,* written by Cornelia Meigs and illustrated by Berta and Elmer Hader. The Macmillan Company, 1928.

All scanned from printed books. Private collection.

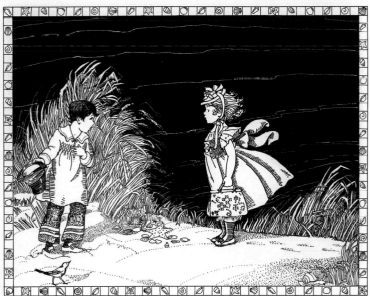

HICKORY, DICKORY, SACARA DOWN

Pen and ink illustration from *Berta and Elmer Hader's Picture Book of Mother Goose,* by Berta and Elmer Hader. Coward-McCann, 1930.

Pen and ink illustration from *Baby Bear, written* by Hamilton Williamson and illustrated by Berta and Elmer Hader. Doubleday, Doran & Co., 1930.

Pen and ink illustration from *Lion Cub: A Jungle Tale,* written by Hamilton Williamson, illustrated by Berta and Elmer Hader. Doubleday, Doran & Co., 1931.

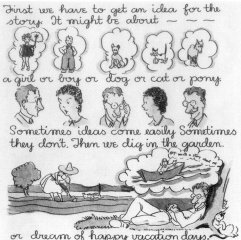

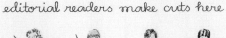

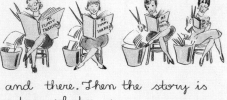

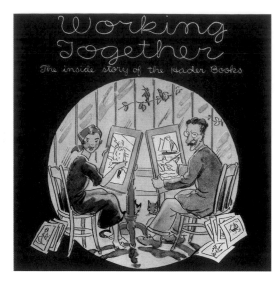

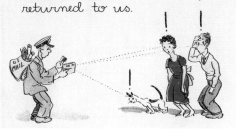

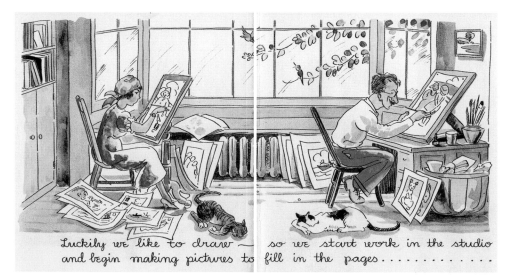

Selected illustrations from *Working Together: The Inside Story of the Hader Books,* by Berta and Elmer Hader (continued on facing page). Published by The Macmillan Company in 1937 to show how Berta and Elmer truly worked together to create their books and illustrations.

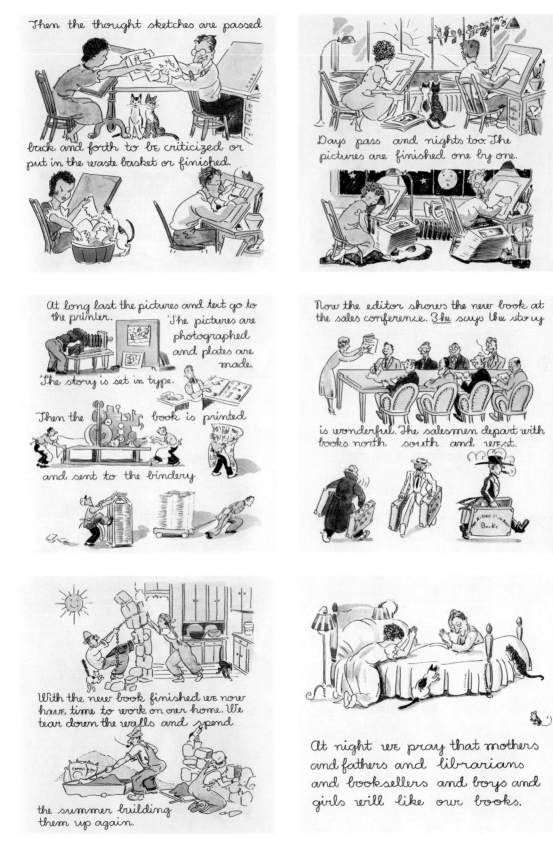

Then the thought sketches are passed

back and forth to be criticized or put in the waste basket or finished.

Days pass and nights too. The pictures are finished one by one.

At long last the pictures and text go to the printer. The pictures are photographed and plates are made.

The story is set in type.

Then the book is printed

and sent to the bindery

Now the editor shows the new book at the sales conference. He says the story is wonderful. The salesmen depart with books north, south, and west.

With the new book finished we now have time to work on our home. We tear down the walls and spend the summer building them up again.

At night we pray that mothers and fathers and librarians and booksellers and boys and girls will like our books.

All illustrations pages 66 and 67 scanned from printed book. Collection Concordia University–Portland.

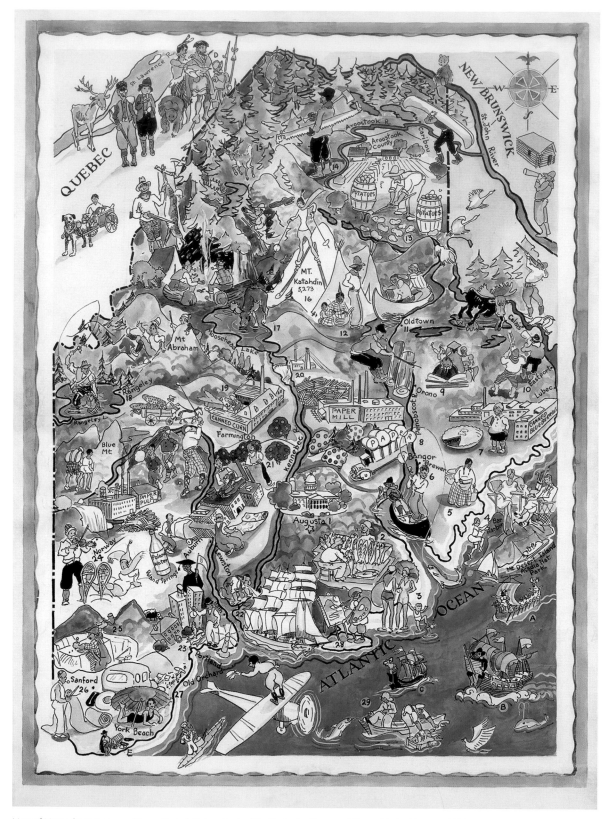

Map of Maine from *Berta and Elmer Hader's Picture Book of the States,* by Berta and Elmer Hader. Harpers, 1932.
Watercolor on illustration board. Scanned from original art board. Collection U of O, AX441, SC 4.
Caricature maps of all the (then 48) states show important historical and geographic features of each state.
Can you find Berta and Elmer in the picture?

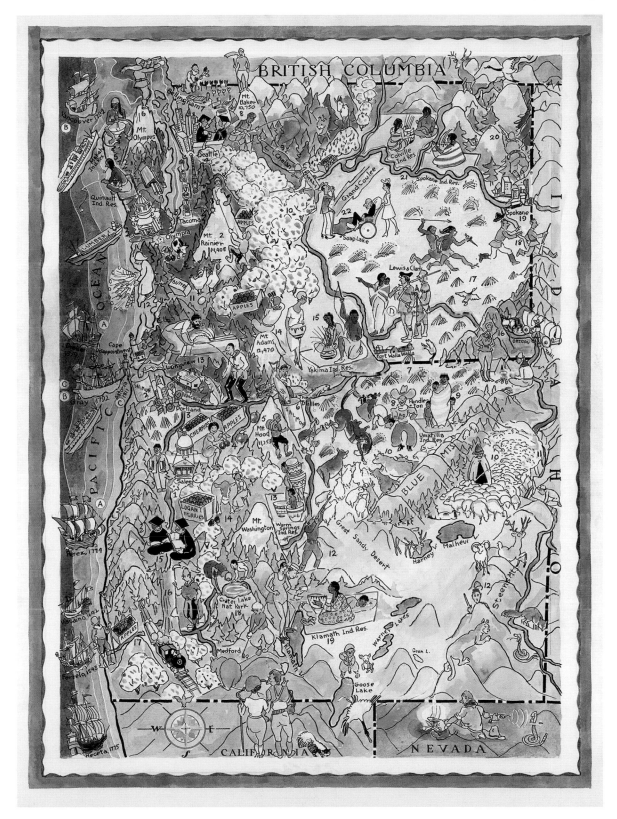

Map of Oregon and Washington from *Berta and Elmer Hader's Picture Book of the States,* by Berta and Elmer Hader. Harpers, 1932. Watercolor on illustration board. Scanned from original art board. Collection U of O, AX441, SC 4.

Caricature maps of all the (then 48) states show important historical and geographic features of each state.

Can you find Berta and Elmer in the picture?

Berta and Elmer sometimes looked to other lands and other cultures for inspiration for their stories.

Illustration from *Banana Tree House,* by Phillis Garrard and illustrated by Berta and Elmer Hader. Coward-McCann, 1938.
Scanned from printed book. Private collection.

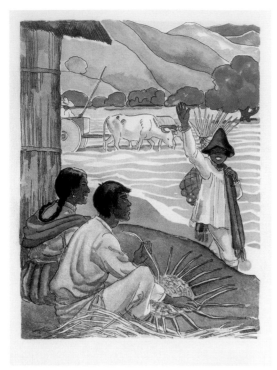

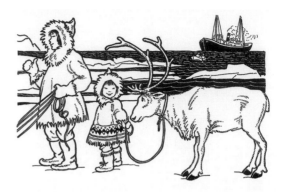

Illustration from *Chuck-a-Luck and His Reindeer,* by Berta and Elmer Hader. Houghton Mifflin Company, 1933.
Black line art. Scanned from printed book. Private collection.

Illustration from *Marcos: A Mountain Boy of Mexico,* by Melicent Humason Lee and illustrated by Berta and Elmer Hader. Albert Whitman Company, 1937.
Pen and ink with watercolor. Scanned from printed book. Private collection.

He had a long spear and a monkey he'd trained to

Illustration from *Baby Bear,* by Hamilton Williamson and illustrated by Berta and Elmer Hader. Doubleday, Doran & Co., 1930.
Black key plate with flat color. Scanned from printed book. Private collection.

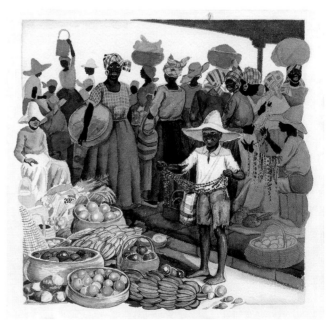

Illustration from *Jamaica Johnny,* by Berta and Elmer Hader. The Macmillan Company, 1935.
Watercolor on illustration board. Scanned from original art board. Collection U of O, AX441, SC 6.

Illustration from *Berta and Elmer Hader's Picture Book of Mother Goose,* by Berta and Elmer Hader.
Coward-McCann, 1930.
Scanned from original art boards.
Collection U of O, AX441, SC 1.
In a rather complicated printing process, a pen and ink black line drawing was made by the Haders, which served as the key plate. From this drawing, blue-line prints (blueprints) were made (the blue lines are invisible to the camera), and on one, a black ink wash was painted in shades of gray for parts of the picture; on the other a full-color watercolor was painted (with no black). The gray and colors were halftoned and layered, color over gray, with the black line printed on top.

Some other early Hader books showing various printing techniques.
(See Glossary for definitions of technical terms.)

Illustration for endsheets from *Tommy Thatcher Goes to Sea,* by Berta and Elmer Hader.
The Macmillan Company, 1937. Scanned from original art board. Collection Concordia University–Portland.
The original drawing, done in ink wash, was printed as a single-color halftone.

Illustration from *Humpy, Son of the Sands,* written by Hamilton Williamson and illustrated by Berta and Elmer Hader.
Doubleday, Doran & Co., 1937. Scanned from printed book.
Private collection.
The black key plate was printed as solid color, and the colors were printed as halftone.

Illustration from *Farmer in the Dell,* by Berta and Elmer Hader.
The Macmillan Company, 1931.
Pen and ink with watercolor on illustration board.
Scanned from original art board.
Collection U of O, AX441, SC 8.
Printed as a CMYK halftone.

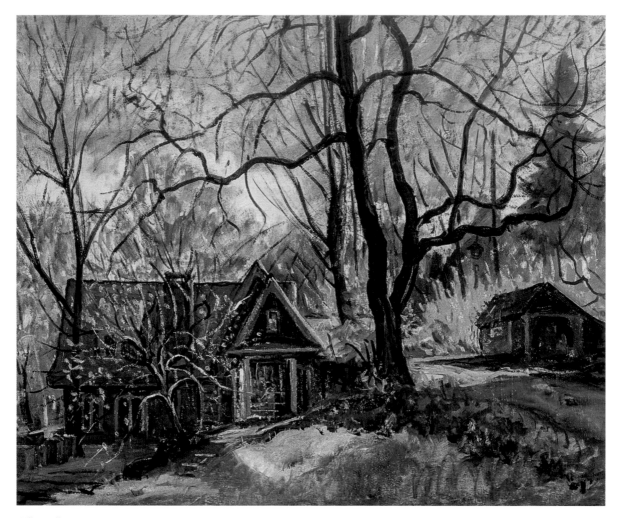

Willow Hill
Elmer Stanley Hader, Nyack, New York, 1957.
Oil on canvas, 20" x 24"
Photo of painting: Collection Concordia University–Portland.

6

Willow Hill

T he brambled, stony hillside in Grand-View-on-Hudson had become theirs in the autumn of 1921. Together the Haders painted a picture of how their imagined house would look on the hillside, designed to capture light and also with entertainment in mind. They even built a model. Since there was an old eighteenth century stone quarry on the land, they had rock available as a building material. They watched stone masons at work and decided they could build their own house. They bought a copy of Flagg's *Small Houses: Their Economic Design and Construction* and began their ambitious project.

The clearing of the brambles and berries began on the seventh of June in 1922. [24] The Haders set to work to refine the house design to fit around chestnuts and willows. Their welcoming home was to be built of wood and stone. The water from several springs was channeled to run beneath the house and then cascade down the hillside. The falls were called Twinkling Waters; the property was christened Willow Hill, and the house became known as the Little Stone House.

Their friend Hamilton Williamson had become their financial advisor. Wanting to help the Haders understand the enormity of the project, she told Berta that it would be possible, even likely, that the actual cost of building the house could run much higher than their estimates, possibly as much as a third higher. Berta looked concerned for a moment but then a smile lit up her face as she responded, "Oh, that's all right. Elmer and I haven't made any estimates." [10]

The myriad friends who typically spent weekends with the Haders continued to do so and became part of the work crew. They helped in the work, knowing that fun was in store within these walls. All the time the house was under construction, Berta and Elmer would arise at four o'clock each morning, a pattern which continued for three years. They moved in just before Christmas in 1925.

According to Rose Wilder Lane, the dining room/studio was 60' x 40' and had a twenty-five-foot ceiling. [50] According to Mary Margaret McBride, it was 32' x 20'. [54] Unarguably, it was big. A stage was at the far end that served as the performance center for readings, skits, musical performances, and more. The musically inclined guests would bring their instruments along with them. Elmer did not have to be prodded to grab the banjo he had crafted with his own hands in his San Francisco days. His fingers flew over the strings, and the mother-of-pearl inlays made from buttons from an old shirt

reflected the warm light.

During the week, the stage was the Haders' illustration studio. The floor-to-ceiling windows at that north end let in the light for the artists at work. The huge dining room table, hand hewn by Elmer from wormed chestnut, could easily seat twenty people and often held half again as many. The main fireplace was nine feet across and typically held six-foot logs. There were a total of seven working fireplaces inside. Berta would later say that by watching the masons, they learned how to build a fireplace, but it was Miska Petersham who taught them how to make a fire. [43] Maud and Miska Petersham were incredibly talented fellow artists who were also under the editorial wing of Louise Seaman Bechtel. She and the Petershams were frequent guests at Willow Hill. Louise spoke of the wonderful company dinners that were held there with one of Berta's marvelous soups as the meal's centerpiece, while a lovely fire blazed.

The four acres were home to Berta and Elmer, their extended human family, and the creatures with whom they shared the land. Mary Margaret McBride said, "Willow Hill has comfortable if, as they put it, Bohemian accommodations for at least fourteen. But then they built the house for their friends—they always said so." [54] The house was for the birds too. There were nineteen birdhouses built into the actual walls outside. Ideas for their books came from many places, but many stories were rooted in Willow Hill. The story of the hand-fed baby bird became *The Friendly Phoebe*. The tale of the rescued baby squirrel became *Squirrely of Willow Hill*. The playful chipmunk, who was one day found in the kitchen eating a blueberry pie, inspired *Little Chip of Willow Hill*. *Little White Foot* was the story of a Willow Hill mouse. *The Runaways* and *Wish on the Moon* were also set on the Hader land. *The Little Stone House* tells the story, in words and pictures, of how they built their home.

Friends talked of the importance of the Haders in their lives. Neighbor Fred Mathias said, "The house sits on top of Willow Hill and with its gentle window eyes overlooks the River Road. As you walk up the path to this house you get the feeling that the trees are nodding their leaves in welcome, and that Twinkling Springs, as crystal clear as ever, are gurgling a cheery hello." [52] Another friend, Jane Varian, wrote of a mutual friend who'd told her, "Sometimes with my recorder I play myself right back into the mood of that wonderful fire-lit room with the Christmas snow rustling against the windows." [70] In a 1926 letter to Berta, Elsie Weil, a dear friend and the editor of *Asia* magazine, said, "Thoughts of you and Elmer in the house on the hill are like winged butterflies to carry us home no matter where we may be." [71]

The Little Stone House was always a "work in progress." In a 1950s letter, the Haders wrote to Louise Seaman Bechtel: "Life moves along in the same old groove in Hader's Hovel. A nicely balanced diet of work and play and work keeps us a step ahead of the sheriff and not too busy with book work to prevent patching and repairing the little cottage we started to build a quarter of a century ago. Just to report a little progress since you last saw the place…we now have door knobs and locks on most all of the doors. Our friends have to be taught how to use them." [31]

Louise wrote of the Haders, "Berta is an expert cook; she entertains twenty or more people without any fluster and looking like a picture in a peasant apron and handkerchief around her curls. Elmer is a fine dancer and a heroic woodchopper. They love music and the theater. I suppose it is natural that people who are so really kind to so many friends; and who do so many daily things in that house so beautifully and merrily, should be able to think of the sort of story-book detail, the expansion and concentration of an author's tale, that children will always love." [4]

Some animals of Willow Hill.

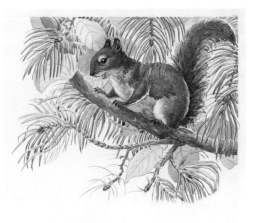

Wish on the Moon, by Berta and Elmer Hader.
The Macmillan Company, 1954.
Scanned from original art board.
Collection U of O, AX441, SC 23.

Wish on the Moon, by Berta and Elmer Hader.
The Macmillan Company, 1954.
Scanned from original art board.
Collection U of O, AX441, SC 23.

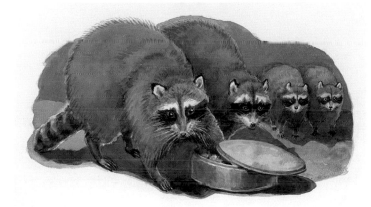

The Runaways: A Tale of the Woodlands,
by Berta and Elmer Hader.
The Macmillan Company, 1956.
Scanned from original art board.
Collection U of O, AX441, Oversized bundle 2.

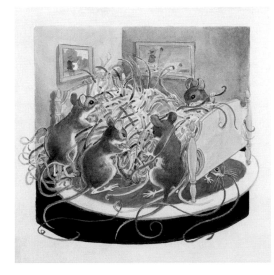

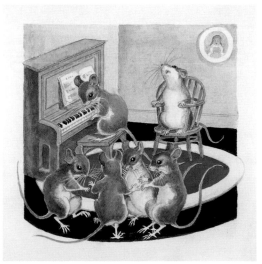

Little White Foot: His Adventures on Willow Hill, by Berta and Elmer Hader.
The Macmillan Company, 1952.
Scanned from original art boards.
Collection U of O, AX441, SC 13.

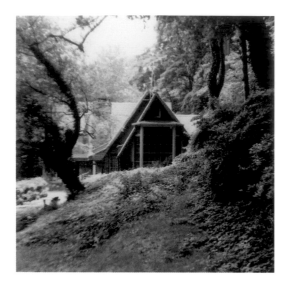
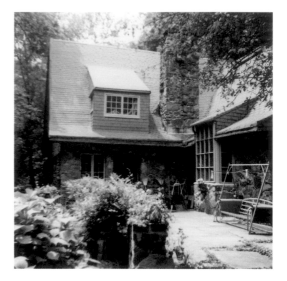

Photos of The Little Stone House at Willow Hill.
Photographers unknown. Collection Concordia University–Portland.

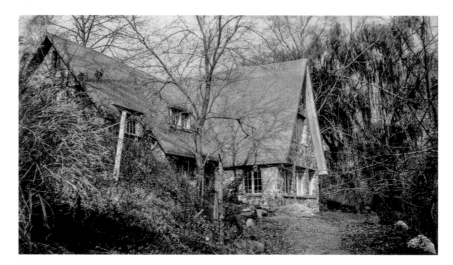

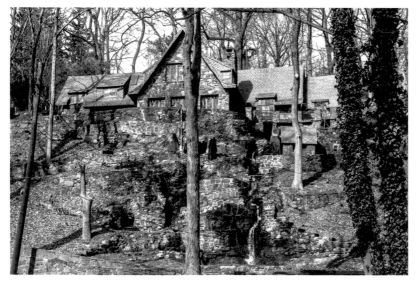

Willow Hill, the Little Stone House, and Twinkling Waters in Grand-View-on-Hudson, Berta and Elmer's home lovingly constructed by their own hands (and those of many friends) over a period of twenty-five years or more.
(Photo shows the view from River Road), Photographer: John Scott, 1990.
Collection The Nyack Library, Nyack, NY.

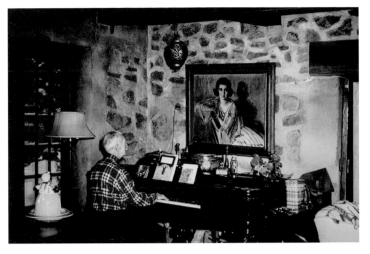

Elmer reminiscing at his piano in the Little Stone House, his 1917 portrait of Berta gracing the wall. Photo taken in 1969. Photographer unknown. Collection Concordia University–Portland.

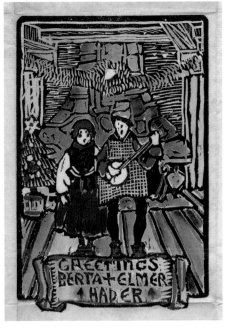

Berta and Elmer's handmade Christmas card of 1923 depicting them in front of their stone fireplace at Willow Hill. Collection Concordia University–Portland.

Photo of the living and dining area in the Little Stone House. Photographer unknown. Collection Concordia University–Portland.

Illustration from *The Little Stone House: A Story of Building a House in the Country*, by Berta and Elmer Hader. The Macmillan Company, 1944. Watercolor on illustration board. Scanned from original art board. Collection U of O, AX441, SC 10.

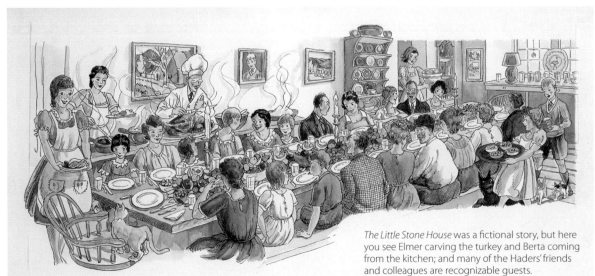

The Little Stone House was a fictional story, but here you see Elmer carving the turkey and Berta coming from the kitchen; and many of the Haders' friends and colleagues are recognizable guests.

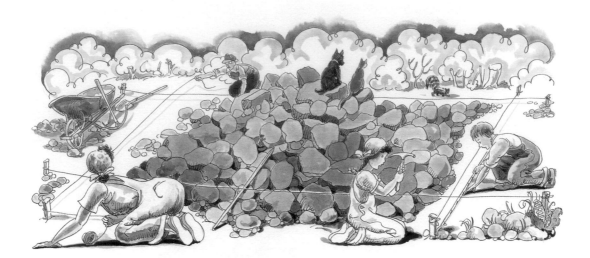

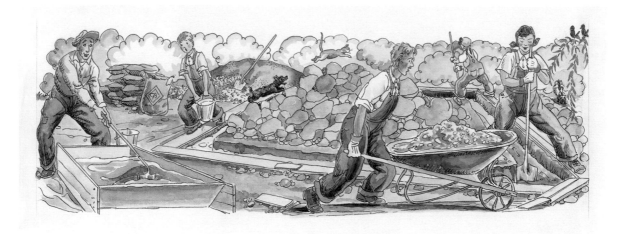

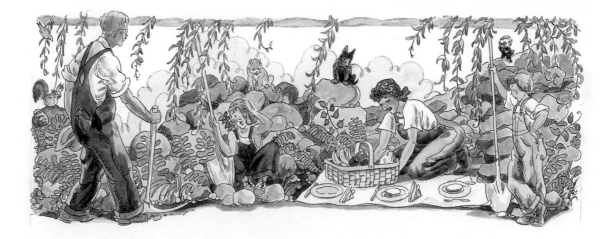

Illustrations from *The Little Stone House: A Story of Building a House in the Country,* by Berta and Elmer Hader.
The Macmillan Company, 1944.
Pen and ink (top) and ink and watercolor (middle, bottom) on illustration board.
Scanned from original art boards.
Collection U of O, AX441, SC 10.

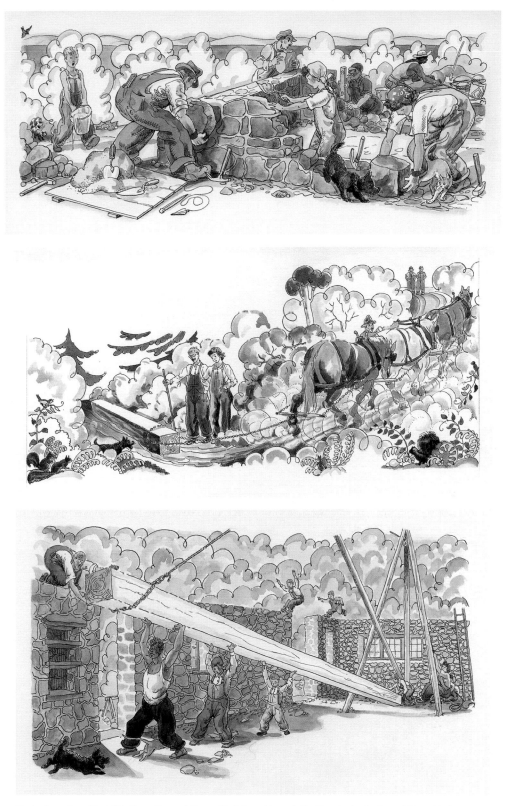

Illustrations from *The Little Stone House: A Story of Building a House in the Country*, by Berta and Elmer Hader.
The Macmillan Company, 1944.
Pen and ink (middle) and ink and watercolor (top, bottom) on illustration board.
Scanned from original art boards.
Collection U of O, AX441, SC 10.

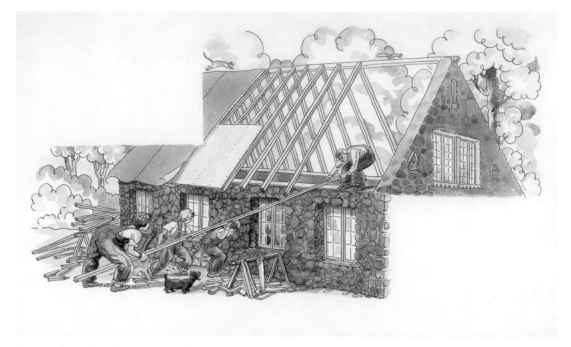

Illustration from *The Little Stone House: A Story of Building a House in the Country,* by Berta and Elmer Hader.
The Macmillan Company, 1944.
Note the bird houses built into the end wall.
Pen and ink and watercolor on illustration board.
Scanned from original art board.
Collection U of O, AX441, SC 10.

Illustration from *The Friendly Phoebe,*
by Berta and Elmer Hader.
The Macmillan Company, 1953.
Little pond at the foot of Twinkling Waters.
Watercolor on illustration board.
Scanned from original art board.
Collection U of O, AX441, SC 7.

Illustration from *Little Chip of Willow Hill,* by Berta and Elmer Hader.
The Macmillan Company, 1958.
Watercolor on illustration board.
Scanned from original art board.
Collection U of O, AX441, SC 9.

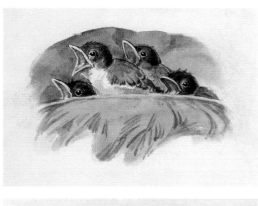

Illustrations from *The Friendly Phoebe,* by Berta and Elmer Hader.
The Macmillan Company, 1953.
Watercolor on illustration board.
Scanned from original art boards.
Collection U of O, AX441, SC 7.

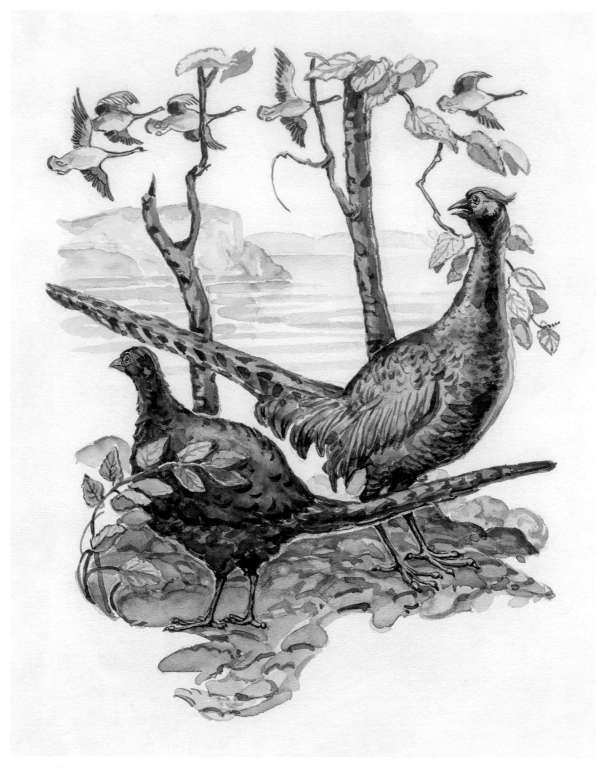

Watercolor illustration from *The Big Snow,* Berta and Elmer's 1949 Caldecott Award book.
The Macmillan Company, 1948.
Scanned from original art board.
Collection U of O, AX441, SC 4a.
(See Credits, page 136.)

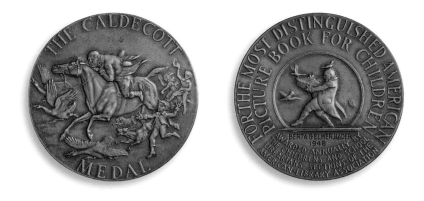

7
Caldecott Award

*I*n 1940 the Haders were recognized as runners-up for the Caldecott Medal for their *Cock-a-Doodle-Doo* book. Doris Patee wrote to Berta and Elmer telling them the good news. In their response letter Elmer wrote, "We do our best each year but when the last word is said and the last touch put on the final illustration there is little anyone can do but pray."[27] *Cock-a-Doodle-Doo* is the story of a baby chick who became separated from his kin. He has many adventures finding his way home. Alternate pages in the book are illustrated with pencil drawings on textured board and with soft colored scenes of nature in watercolor. A realistic quality is captured in the look of every animal. So, too, is the emotion of the baby chick.

In 1944 they were again honored as runners-up, this time for *The Mighty Hunter*. Little Brave Heart had to learn the hard way that it is better to hunt for knowledge than to hunt only for fun. These illustrations also alternate from pencil drawings to beautifully rendered, softly colored scenes of Little Brave Heart and a variety of animals. Exquisite drawing and painting technique, beauty, and feeling abound on every page. (Berta was occasionally called Bertha, and, unfortunately, this mistake was made on the cover of the first run of *The Mighty Hunter* in the edition produced by Scholastic in 1964. Berta's name was printed as Bertha.[11])

The coveted Caldecott Medal was bestowed upon Berta and Elmer Hader in 1949 for *The Big Snow*. They were incredibly pleased and humbled. The Caldecott Medal has been presented each year since 1938 by the Association for Library Service to Children to the illustrator(s) they consider to have created the most distinguished picture book published in the United States in any given year. The Haders had been inspired to write *The Big Snow* because of a huge storm which dumped record amounts of snow and made it hard for the animals to find food. The book is about compassion, cooperation, and kindness. It is about seeing a need and making a difference. The illustrations are, in typical Hader fashion, well-drawn, accurate, charming, and uncluttered. The Caldecott committee deemed their illustrations the best of the best that year.

Mary Margaret McBride said, "Probably never have so many rejoiced so sincerely over an honor as over the award of the Caldecott Medal to Berta and Elmer Hader for their book, *The Big Snow* as 'the most beautiful picture book for children' in 1948. That is because Berta and Elmer are unique

in their capacity for friendship—genuinely happy when good luck comes to others, honestly distressed when the news is bad. And for a wonder, people pay them back in the same coin." [54]

Elmer gave the acceptance speech at the award presentation ceremony. He said, "Snow started on Christmas night. It was a lovely snow that kept going. News reports over the radio gave the story of the big snow that had broken all records since the blizzard of '88. The Audubon Society broadcast an appeal for everyone to put out seeds, or crumbs, for the birds whose food supply was buried under mountains of snow. We found ourselves asking 'how would these feathered children of the great outdoors survive?' This was the germ of the idea for a picture book and *The Big Snow* wrote itself. That it became a popular book with young readers when published in the fall pleased us. That it was approved by librarians and given the medal by the Caldecott Award Committee of the American Library Association was a surprise and one of the nicest things that ever happened to us." [23]

Berta and Elmer had, in typical fashion, written the acceptance speech together. The night of the ceremony Elmer went on sharing their thoughts, feelings, and grace by thanking others dedicated to delighting children. They shared their appreciation for dedicated librarians, caring booksellers, talented teachers, and "young women of ability and imagination in the world of children's books: [editors] Louise Seaman, May Massee, Bertha Gunterman, Helen Dean Fish, Virginia Kirkus and Doris Patee." They acknowledged the "stimulating and wise counsel" of Frederic Melcher, the man who was most proactively involved in the world of children's literature. It was he who proposed the Newbery and Caldecott Medal awards. But even he didn't get Berta and Elmer's biggest "thank you." They saved that for the readers of their books: the children. [23]

The printers were embarrassed that they'd made a page-order error on the first printing on that which was to become such an honored book. It was never explained how it happened but the printers reversed the center pages in the first edition of *The Big Snow*. It was corrected in all successive editions. [60]

The Haders were told by Virginia Patterson of the advertising department at Macmillan that there would be a photo shoot of important authors and illustrators done by *Life Magazine* in March of 1950. They were to attend the black tie affair. Virginia wrote, "Berta need not wear a black tie and Elmer should wear something else in addition to the tie." [63]

Berta and Elmer Hader's Caldecott Honors-winning books *Cock-a-Doodle-Doo*, The Macmillan Company, 1939 (left), and *The Mighty Hunter*, The Macmillan Company, 1943 (right). Scanned from original art boards. Collection U of O, AX441, SC 5 (left); SC 13 (right).

Berta and Elmer Hader's Caldecott Award-winning book *The Big Snow*. The Macmillan Company, 1948. (See Credits, page 136.)

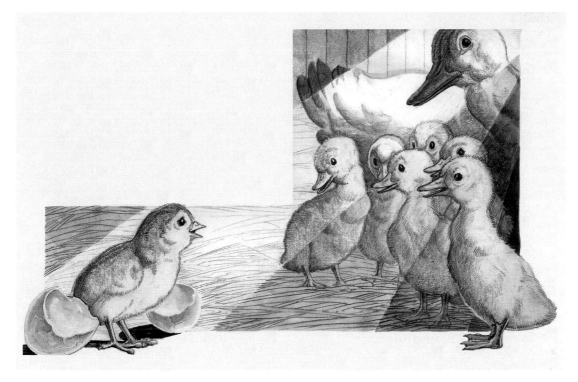

Pencil illustration from *Cock-a-Doodle-Doo,* Berta and Elmer's 1940 Caldecott Honors book. The Macmillan Company, 1939.
Scanned from original art board.
Collection U of O, AX441, SC 5.

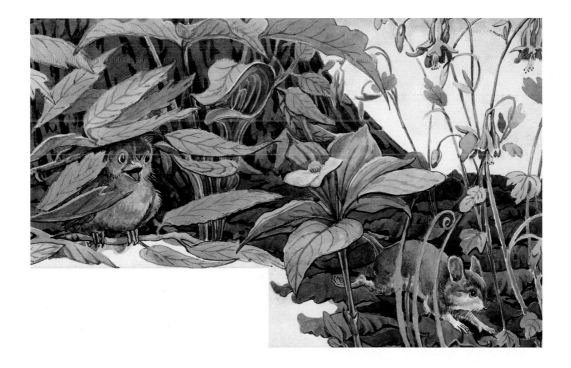

Watercolor illustration from *Cock-a-Doodle-Doo,* Berta and Elmer's 1940 Caldecott Honors book. The Macmillan Company, 1939.
Scanned from original art board.
Collection U of O, AX441, SC 5.

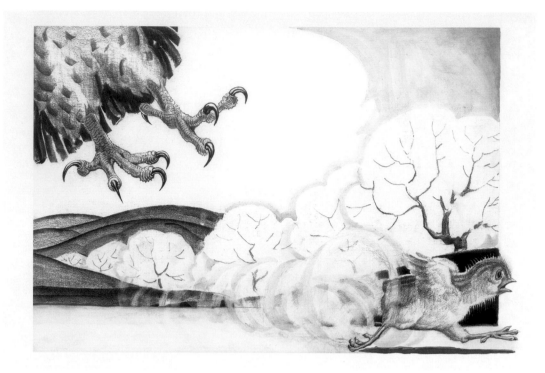

Pencil illustration from *Cock-a-Doodle-Doo,* Berta and Elmer's 1940 Caldecott Honors book.
The Macmillan Company, 1939.
Scanned from original art board.
Collection U of O, AX441, SC 5.

Watercolor illustration from *Cock-a-Doodle-Doo,* Berta and Elmer's 1940 Caldecott Honors book.
The Macmillan Company, 1939.
Scanned from original art board.
Collection U of O, AX441, SC 5.

Watercolor illustration from *The Mighty Hunter,* Berta and Elmer's 1944 Caldecott Honors book.
Text is hand-lettered by the Haders.
The Macmillan Company, 1943.
Scanned from original art board.
Collection U of O, AX441, SC 13.

Pencil illustration from *The Mighty Hunter,* Berta and Elmer's 1944 Caldecott Honors book. Text is hand-lettered by the Haders.
The Macmillan Company, 1943.
Scanned from original art board.
Collection U of O, AX441, SC 13.

He often sat looking at the picture writing on the buffalo hides that hung on the walls of the tepee. His father was a great hunter and a brave man, but he had never gone to school. Little Brave Heart thought it would be more fun to go hunting than to go to school.

Watercolor illustration from *The Mighty Hunter,* Berta and Elmer's 1944 Caldecott Honors book. Text is hand-lettered by the Haders.
The Macmillan Company, 1943.
Scanned from original art board.
Collection U of O, AX441, SC 13.

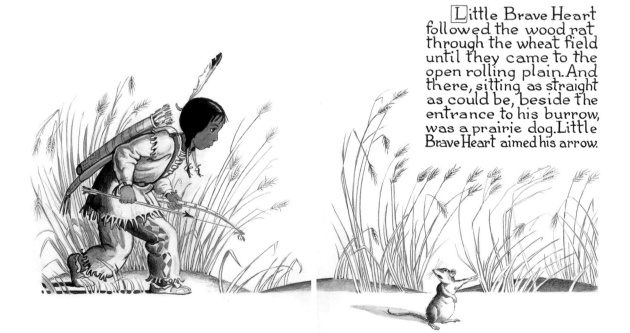

Little Brave Heart followed the wood rat through the wheat field until they came to the open rolling plain. And there, sitting as straight as could be, beside the entrance to his burrow, was a prairie dog. Little Brave Heart aimed his arrow.

Pencil illustration from *The Mighty Hunter,* Berta and Elmer's 1944 Caldecott Honors book. Text is hand-lettered by the Haders.
The Macmillan Company, 1943.
Scanned from original art board.
Collection U of O, AX441, SC 13.

Pencil illustrations from *The Big Snow*, Berta and Elmer's
1949 Caldecott Award book.
The Macmillan Company, 1948.
Scanned from original art board.
Collection U of O, AX441, SC 4a.
(See Credits, page 136.)

Watercolor illustration from
The Big Snow, Berta and Elmer's
1949 Caldecott Award book.
The Macmillan Company, 1948.
Scanned from original art board.
Collection U of O, AX441, SC 4a.
(See Credits, page 136.)

Pencil illustration from *The Big Snow,*
Berta and Elmer's 1949 Caldecott
Award book.
The Macmillan Company, 1948.
Scanned from original art board.
Collection U of O, AX441, SC 4a.
(See Credits, page 136.)

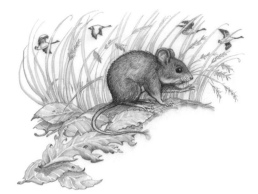

Watercolor illustration from *The Big Snow,* Berta and Elmer's
1949 Caldecott Award book.
The Macmillan Company, 1948.
Scanned from original art board.
Collection U of O, AX441, SC 4a.
(See Credits, page 136.)

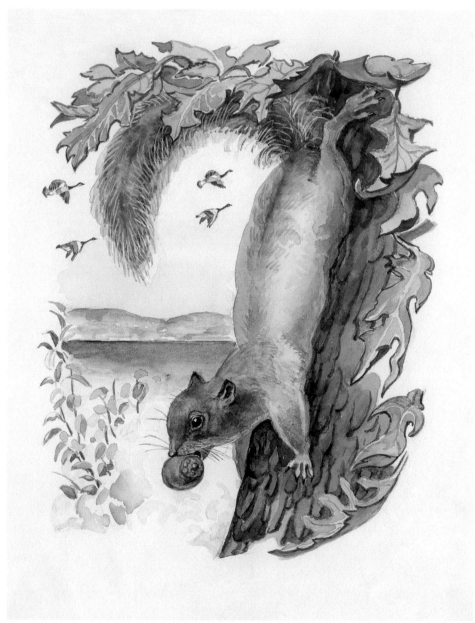

Watercolor illustration from *The Big Snow,* Berta and Elmer's 1949 Caldecott Award book.
The Macmillan Company, 1948.
Scanned from original art board.
Collection U of O, AX441, SC 4a.
(See Credits, page 136.)

Pencil illustration from *The Big Snow,*
Berta and Elmer's 1949 Caldecott
Award book.
The Macmillan Company, 1948.
Scanned from original art board.
Collection U of O, AX441, SC 4a.
(See Credits, page 136.)

Pencil illustration from *The Big Snow,* Berta and Elmer's
1949 Caldecott Award book. The Macmillan Company, 1948.
Scanned from original art board.
Collection U of O, AX441, SC 4a.
(See Credits, page 136.)

Watercolor illustration from *The Big Snow,* Berta and Elmer's
1949 Caldecott Award book. The Macmillan Company, 1948.
Scanned from original art board.
Collection U of O, AX441, SC 4a.
(See Credits, page 136.)

Illustration from *Little White Foot: His Adventures on Willow Hill*, by Berta and Elmer Hader. The Macmillan Company, 1952. Watercolor on illustration board. Scanned from original art board. Collection U of O, AX441, SC 13.

8

Later Books

The Haders won the Caldecott Medal at mid-career. Prior to *The Big Snow* they had written thirty-seven of their own children's books, also illustrating thirty-six more for other writers. In producing so many books, they had created quite a rapport with—and were well respected by—their editors. That respect showed itself in a variety of ways. When the art work for *The Big City* was returned to the Haders, a woman in the Macmillan art department confessed that there was one original missing because Doris Patee didn't want to take it down from its honored position hanging over her desk.[40]

Berta and Elmer did continue to come up with a multitude of ideas for children's books. Doris said that they usually had at least a dozen good ideas for books percolating within them at any given time. She encouraged them to take a step back, relax, and aim for one book a year. Berta and Elmer took her advice. Twenty-four more of their own books, as well as two for other authors, were produced in the second half of their juvenile book career. They continued to work on Willow Hill. Elmer began to paint again. They were no longer the book-a-month Haders.

They did continue to carefully research facts to be included within their books, though probably at a more leisurely pace. It was not unusual to run into these "gentle, friendly folks" at the Nyack Library. They also took great interest in current events, and wrote books using those events as themes. Reindeer were being relocated in the Arctic and the book *Reindeer Trail* told the tale. Bridges and freeways were being created, and the story of displaced wildlife was captured in *The Runaways*. *Home on the Range* depicts the scenery and character of the area from their trip to Wyoming to visit Elmer's brother, Waldo.

In the early 1950s the Haders wrote, "Ideas for our books come from every direction—from memories of our own childhoods, from experiences we have had with animals and children, visits to museums and zoos, and from stories that we have read or heard about. Usually, we each work out an idea with rough drawings in a sketchbook called a dummy. Then we compare notes, talk over what we have done, choose one of the ideas, or possibly combine the two ideas, make suggestions, cross out or add material and decide which illustrations will be done in pencil, pen and ink or water color [*sic*]. Little by little a book takes shape.

"As a book progresses, lapses in our memories often require us to do a great deal of research. A book can take years to develop or it may be finished in a few weeks. Sometimes the animal or human character runs away with the plot. Then everything moves fast, and we may even beat the deadline our editor has given us!

"Most important to us, besides writing and illustrating books, is our big interest in working in any way we can to save the natural beauty of this wonderful country. Conservation of wild life [*sic*] is so important to the joy of living. We hope our books give children pleasure as well as an awareness of the charm of animals and beauties of nature everywhere." [17]

Berta and Elmer dedicated themselves to increasing awareness of the need for good conservation practices. Elmer was the zoning administrator of Grand-View-on-Hudson for forty-six years. He also served as Vice President of the Hudson River Conservation Society, and both he and Berta were on the citizen's committee opposing the original landfall plan for the Tappan Zee Bridge. [36] These efforts accounted for the bridge having a curve to it rather than running straight into and ruining the village, as originally planned.

Their books continued to be in high demand, and the Haders were still very active in promoting them. In a letter to Macmillan Senior Editor Jeremiah Kaplan, written in 1962, they suggested an idea for marketing *Little Antelope*. They proposed that a scholarship grant to Harvard be awarded for the best letter from a five year old stating why *Little Antelope* was his/her choice for the Nobel Prize in Literature. [29] Mary Margaret McBride continued to mention the Haders on her show regularly, talking about them and their books, giving them more air time than any other subjects. She even arranged with Berta and Elmer to broadcast from their front terrace for an entire month one summer.

The book world continued to change. In a 1964 letter to Marian Webb, long-time head librarian of the children's section at the Fort Wayne Indiana Library, the Haders wrote about the changes in the children's book world that they'd seen during their career: "The present high cost of paper, engraving, printing and binding are factors that influence the quality of books. But each year the list of new books for the juvenile market grows longer and many good books may be overlooked in the shuffle." They went on to say that in the beginning of their career, "Artists and writers and editors working on children's books, all knew each other." And, "Since there weren't so many books published in our field, all of us were able to look at the new books to see what others were doing. At first about sixty or seventy new books were published each Fall, but soon the list began to grow, until last year 2,976 new children's books appeared. It is obvious that no one has time to look at them all, not even the best sellers." [32]

Yes, the world of children's books was definitely changing. In a letter from Frances Keene, editor in the Children's Book Department at Macmillan, written in 1963, she suggested that when thinking of future books with Macmillan, the Haders seriously consider changes in the way they prepared their art, based on cost concerns. [44] The Haders had a history of negotiating with their editors for art and printing techniques to be used and numbers to be run. They were used to discussions rather than absolute directives. The publishing protocols began to seem more rigid to the Haders.

Berta and Elmer's creative minds continued to come up with book ideas well into their eighties. They roughed out plans for a sequel to *Tommy Thatcher Goes to Sea* and a new book with the working title *Humpty Dumpty Before the Fall*. There are unpublished manuscripts entitled *High Tor: The History of a Mountain* and *A Crown for Powhatan*. Ideas abounded, but their last published book was *Two is Company, Three's a Crowd: A Wild Goose Tale*. It was released in 1965.

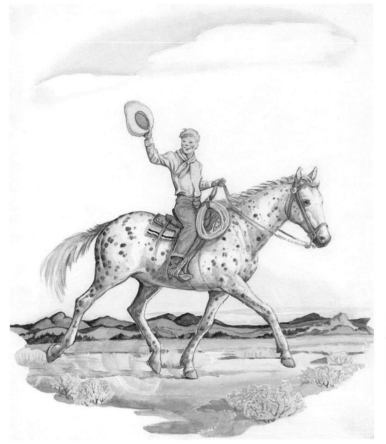

Illustration from *Little Appaloosa*, by Berta and Elmer Hader.
The Macmillan Company, 1949.
Watercolor on illustration board. Scanned from original art board.
Collection U of O, AX441, SC 9.

Illustrations from *Little Appaloosa*, by Berta and Elmer Hader.
The Macmillan Company, 1949.
Pencil on illustration board. Scanned from original art board.
Collection U of O, AX441, SC 9.

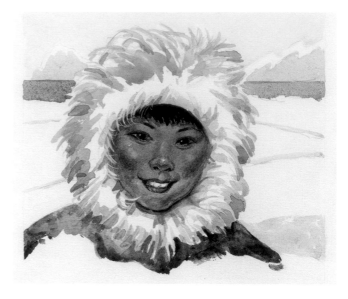

Illustrations from *Reindeer Trail: A Long Journey From Lapland to Alaska,* by Berta and Elmer Hader.
The Macmillan Company, 1959.
Watercolor on illustration board. Scanned from original art boards.
Collection U of O, AX441, SC 16.

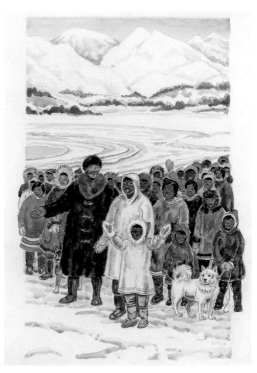

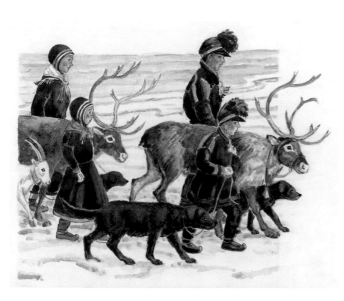

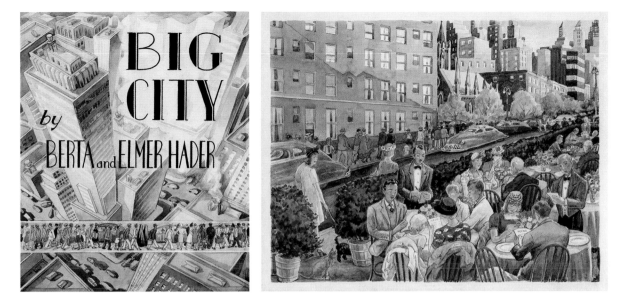

Dust jacket (left) and interior illustration (right) from *Big City,* by Berta and Elmer Hader.
The Macmillan Company, 1947.
Watercolor on illustration board. Scanned from original art boards.
Collection U of O, AX441, SC 4.

Illustrations from *Little Town,* by Berta and Elmer Hader.
The Macmillan Company, 1941.
Pen and ink on illustration board. Scanned from
original art boards.
Collection U of O, AX441, SC 11.

A few of the Haders' reference sketches and notes for various book projects.
Pencil on drawing paper. Scanned from originals.
Collection U of O, AX441, Box 5: Hader Sketchbook.

Illustration from *Little Antelope: An Indian for a Day*, by Berta and Elmer Hader.
The Macmillan Company, 1962
Watercolor on illustration board. Scanned from original art board.
Collection U of O, AX441, SC 11.

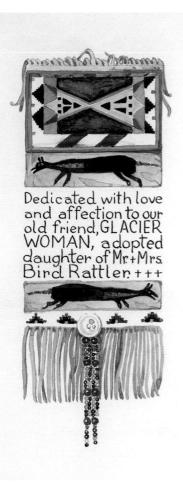

Illustration from dedication page of *The Mighty Hunter*, by Berta and Elmer Hader.
The Macmillan Company, 1943.
Watercolor on illustration board.
Scanned from original art board.
Collection U of O, AX441, SC 13.

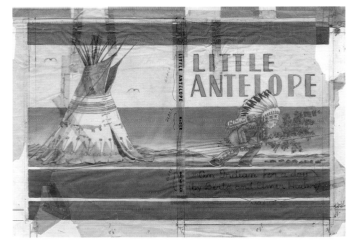

Book jacket design for *Little Antelope: An Indian for a Day*,
by Berta and Elmer Hader.
The Macmillan Company, 1962.
Watercolor on illustration board,
with tissue paper overlay for notes
on position and color of type,
measurements, and crop marks.
Scanned from original art board.
Collection U of O, AX441, SC 11.

Illustration from *Little Antelope:
An Indian for a Day*,
by Berta and Elmer Hader.
The Macmillan Company, 1962.
Pencil on illustration board.
Scanned from original art board.
Collection U of O, AX441, SC 11.

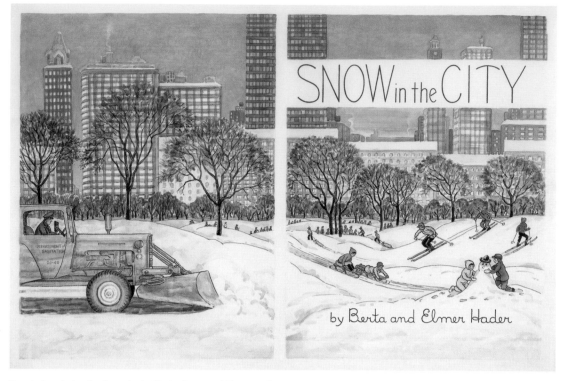

Dust jacket design for *Snow in the City,* by Berta and Elmer Hader.
The Macmillan Company, 1963.
Watercolor on illustration board. Scanned from original art board.
Collection U of O, AX441, Oversized bundle 6.

Illustration from *Lost in the Zoo,*
by Berta and Elmer Hader.
The Macmillan Company, 1951.
Watercolor on illustration board.
Scanned from original art board.
Collection U of O, AX441,
Oversized bundle 4.

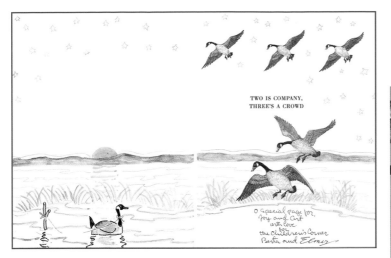

Dedicatory watercolor for *Two is Company, Three's a Crowd,*
1965, the Haders' last published book.
Scanned from original in book inscribed to Berta's niece,
Joy, and her family.
Private collection.

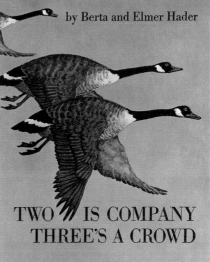

Dust jacket for *Two is Company, Three's a Crowd,* by
Berta and Elmer Hader (their last published book).
The Macmillan Company, 1965
Scanned from printed jacket.
Private collection.

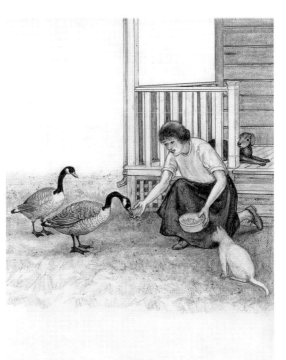

Pencil illustrations for *Two is Company,
Three's a Crowd,* by Berta and Elmer Hader.
The Macmillan Company, 1965.
Scanned from original art boards.
Collection U of O, AX441, SC 22.

Elmer's Valentine to Berta, 1967. (Elmer made this banjo for himself before he met Berta and played it all his life.)
Scanned from original.
Collection U of O, AX441, Addenda, SC 4a.

9

Dedicatory Watercolors, Cameos, and Illustrated Letters

Many authors and artists autograph their work. Berta and Elmer took it to the next level. It became their custom to personalize a gift book by creating a unique watercolor painting on the half title page. It nearly always showed Berta and Elmer with one of the book characters in a scene befitting the book. The Haders had a multitude of skills. One of them was painting these watercolors without causing wrinkling or buckling to the paper. If their intent was to make the recipient feel special, they hit their mark every time.

Another technique they used to delight was their cameo on the copyright page. This was a tradition born in 1929, applauded by fans, and appearing in nearly every book they authored during their entire career. The cameo was most often a small, simple pencil sketch, though sometimes, as in *Green and Gold* for example, it was an elaborate color sketch tied to the dedication page illustration opposite. Whether presented in color or in black and white, Berta and Elmer were always wearing the clothes and engaging in the activities that tied their caricatures into the book. Rose Dobbs, children's book author, publisher, and critic, stated, "These hilarious self-portraits viewed in chronological order present a rare, tongue-in-cheek thumbnail autobiography. Always in keeping with the book at hand, they show the Haders at home, farming, building, cozily sitting by the fire or digging themselves out of the snow; and abroad as travelers, sailors, tourists, vacationists."[12]

In *Berta and Elmer Hader's Picture Book of the States,* which presented whimsical maps of all of the states in the Union (1932), Berta and Elmer did not limit their cameos to just the copyright page. The Haders' sense of humor was evident as they added themselves as characters in each map, to the delight of the readers who loved to search each page for the characters with the big nose and the curly hair.

The readers did certainly enjoy the fanciful self portraits, though they probably had no idea that the Hader family, friends, and/or business associates were treated to amusing cartooned Haders on a regular basis. It was Berta and Elmer's custom to illustrate virtually every letter they sent, and they were prolific letter writers! Here, their light-hearted humor and personalities were free to show themselves without editorial intervention. These clever and entertaining communications delightfully and humorously depicted the Haders' excitement about a party, project, or upcoming event; or the

audience reaction at a presentation; or Berta and Elmer happily waving from a car as they began a trip. Rose Dobbs was right about the Hader book cameos showing a thumbnail autobiography. But their unique and graphic letters, if gathered together, would show a complete and thorough autobiography: one that would take the reader on a joyous adventure.

Two different unique, personalized dedicatory watercolors for *The Big Snow,* 1948.
Private collection.

Unique, personalized dedicatory watercolor for *Rainbow's End,* 1945.
Private collection.

Unique, personalized dedicatory watercolor for *Lost in the Zoo,* 1951.
Private collection.

Unique, personalized dedicatory watercolor
from *Skyrocket*, 1946.
Private collection.

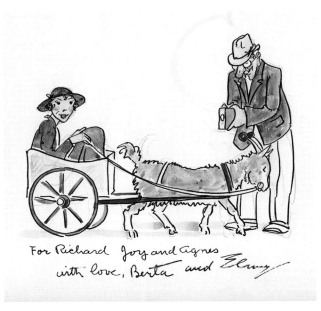

Unique, personalized dedicatory watercolor from *Billy Butter*, 1936.
Private collection.

Unique, personalized dedicatory watercolor from *Cricket,
the Story of a Little Circus Pony*, 1938.
Private collection.

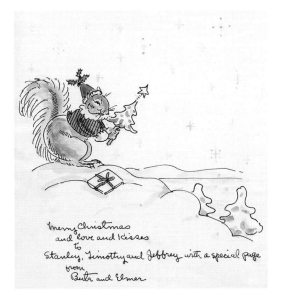

Unique, personalized dedicatory watercolor from *Lost in the
Zoo*, 1951.
Private collection.

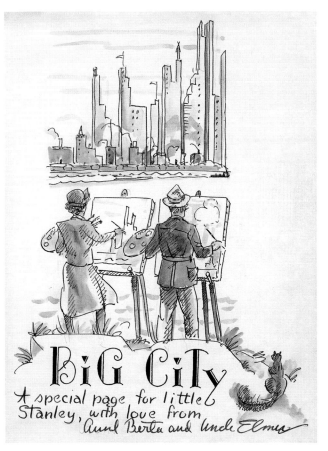

Unique, personalized dedicatory watercolor from *The Big City*, 1947.
Private collection.

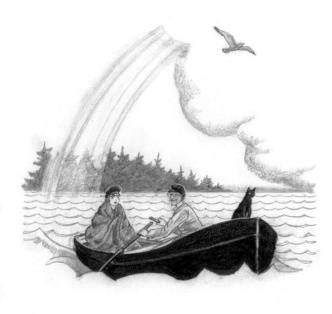

Cameo for *Rainbow's End,* by Berta and Elmer Hader. The Macmillan Company, 1945.
Pencil on illustration board. Scanned from original art board.
Collection U of O, AX441, SC 16.

Cameo for *Little Antelope: An Indian for a Day,*
by Berta and Elmer Hader.
The Macmillan Company, 1962.
Pencil on illustration board. Scanned from
original art board.
Collection U of O, AX441, SC 11.

Cameo for *Cricket, the Story of a Little Circus Pony,*
by Berta and Elmer Hader.
The Macmillan Company, 1938.
Ink on illustration board. Scanned from
original art board.
Collection U of O, AX441, SC 6.

Cameo for *Midget and Bridget,* by Berta and Elmer Hader.
The Macmillan Company, 1934.
Ink on illustration board. Scanned from original art board.
Collection U of O, AX441, SC 14.

Cameo from *The Big Snow,* by Berta and Elmer Hader. The Macmillan Company, 1948.
Pencil on illustration board. Scanned from original art board.
Collection U of O, AX441, SC 4a.
(See Credits, page 136.)

Cameo from *Cock-a-Doodle-Doo, the Story of a Little Red Rooster,* by Berta
and Elmer Hader.
The Macmillan Company, 1939.
Pencil on illustration board. Scanned from original art board.
Collection U of O, AX441, SC 5.

Cameo from *Snow in the City, a Winter's Tale,*
by Berta and Elmer Hader.
The Macmillan Company, 1963
Ink on illustration board. Scanned from
original art board..
Collection U of O, AX441, SC18/19.

Berta and Elmer's letter to Doris Patee, date unknown. Collection U of O, AX441, Box 1, Correspondence, Outgoing.

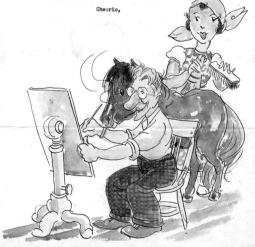

Berta and Elmer's letter to Doris Patee, December 20, 1944. Collection U of O, AX441, Box 1, Correspondence, Outgoing, Patee binder.

Berta and Elmer's letter to Doris Patee, regarding *Spunky*. Collection U of O, AX441, Box 1, Correspondence, Outgoing, Patee binder.

Berta and Elmer's letter to Doris Patee, regarding *Cricket*. Collection U of O, AX441, Box 1, Correspondence, Outgoing, Patee binder.

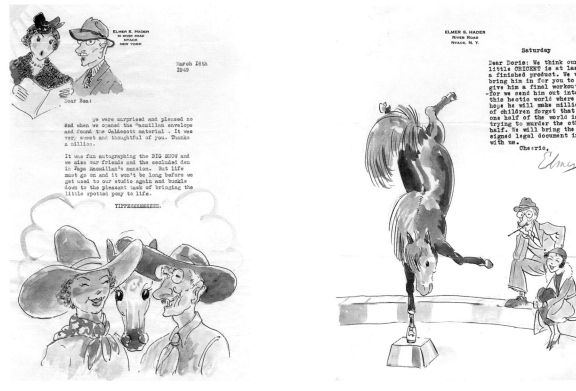

Berta and Elmer's letter to Bea, an editor at Macmillan, 1949. Collection U of O, AX441, Box 1, Correspondence, Outgoing, Patee binder.

Berta and Elmer's letter to Doris Patee, regarding *Cricket*. Collection U of O, AX441, Box 1, Correspondence, Outgoing, Patee binder.

Two of Elmer's illustrated letters to Berta. Collection U of O, AX441, Box 2, Correspondence, Outgoing.

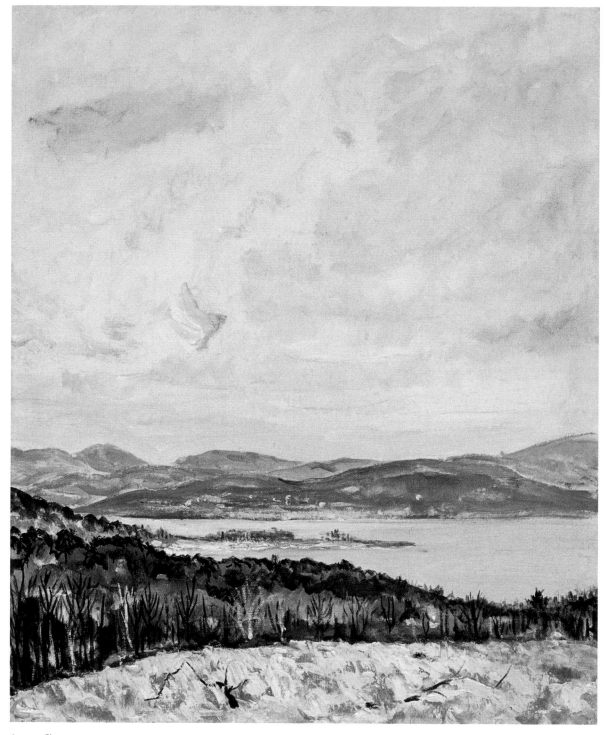

January Sky
Elmer Stanley Hader, West Shokan, New York, 1956.
Oil on canvas board, 24" x 20".
Photo of painting: Collection Concordia University–Portland.

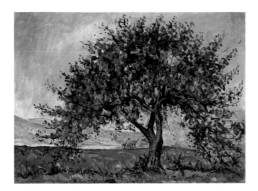

10
Elmer's Later Oils

Elmer painted a portrait of Latrobe Carroll, a friend and peer, in 1923. Shortly after that painting was completed, Berta and Elmer's beloved little son Hamilton died of spinal meningitis. Elmer didn't pick up his oils again until 1942. In those intervening years he had dedicated himself to building his home and career and helping with conservation efforts in the Hudson River Valley. But in the 1940s his empty easel called his name. Elmer and Berta went on vacation to Maine in 1942, and Elmer decided to answer that call.

He took to painting *en plein air* (outdoors on location), and many of his oils from this era were painted on masonite, board, or canvas board instead of stretched canvas, possibly because these were easier to carry into the field. Elmer liked to do a sketch each morning to keep his eye and hand trained. He was a keen observer of color, texture, light, and beauty and began to capture these again with his paints with such skill that Sandy Hunter of California Art Gallery declared that "no one knows values like Elmer Hader." His painting style evolved from that of his youthful years to a looser, freer expression. Though still impressionistic in style, these new works exhibited a change in technique. Elmer deviated from the thick, textural impasto application of paint typical of his earlier works and thinned his paints almost to watercolor consistency, working quickly but decisively. He was able to create the accurate impression of reality with deft, simple, well-placed brush strokes and colors in just the right values. At the end of a day of painting, this experienced artist often had several finished paintings.

Many of Elmer's paintings were done as series. This allowed Elmer to study a place in depth from different points of view and in different seasons and explore variations in light, color, and composition. The Goose Cove series was painted in West Tremont, Maine, near Bessie Beatty's home. The Silver Lake series was painted in the Catskills of New York near Stella Karn's farm. Stella, manager of Mary Margaret McBride's radio career, was a frequent visitor to Willow Hill and happily invited the Haders for reciprocal visits. Some landscapes depict the Ashstran Reservoir which is adjacent to West Shokan, also near Stella's property.

There was a Haitian series, which included bright and colorful scenes of daily living simply portrayed, much like the Telegraph Hill paintings done thirty years earlier. The paintings depicted life in rural settings showing the landscapes and people who inhabited them. While on their trip to Haiti,

the Haders conceived of the idea of writing the story of the banana. Elmer's Haitian paintings served as reference material for the resulting book, *Green and Gold.*

As he returned to his oils during his 50s and 60s, Elmer painted mainly for his own pleasure, which gave him the freedom to experiment and paint subjects that were attractive and meaningful to him, without concern about whether others would show or buy his work. Many of these later paintings were given as gifts to friends and family. Others were simply stored away in the Haders' attic, to be rediscovered with delight and wonder after Berta and Elmer were gone. Like much of the Haders' mutual art, Elmer's oils live on.

The Dark Hill
Elmer Stanley Hader, Goose Cove, West Tremont, Maine, 1942.
Oil on canvas board, 18" x 24".
Photo of painting: Collection Concordia University–Portland.

The Seaside
Elmer Stanley Hader, Goose Cove,
West Tremont, Maine, 1942.
Oil on canvas board, 16" x 20".
Photo of painting: Collection
Concordia University Portland.

Berta and Elmer's letter to Bessie
Beatty's husband Bill Sauter,
date unknown.
Collection U of O, AX441, Box 5,
Illustrated letters.

Goose Gables (Bessie Beatty's Maine residence where Haders often visited)
Elmer Stanley Hader, Goose Cove, Maine, 1942.
Oil on canvas board, 18" x 24".
Photo of painting: Collection Concordia University–Portland.

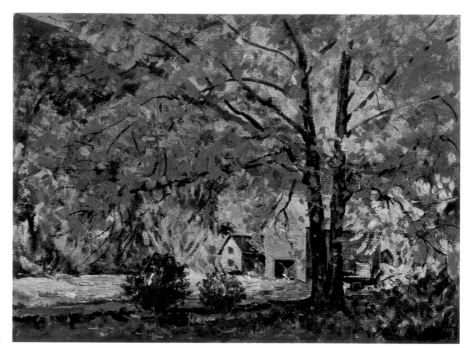

The Maple Tree
Elmer Stanley Hader, West
Shokan, New York, 1943.
Oil on canvas board, 18" x 24".
Photo of painting: Collection
Concordia University–Portland.

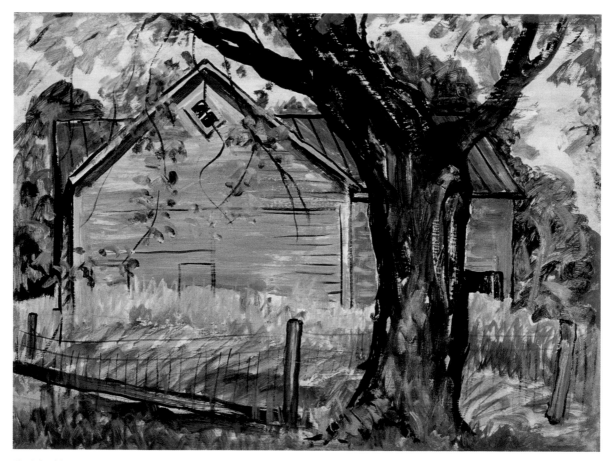

The Side of the Barn (Note the loose, almost scribbly strokes in the grasses; yet, at a distance, it reads as grass luminous with sunshine.)
Elmer Stanley Hader, West Shokan, New York, 1948.
Oil on Masonite, 18" x 24".
Photo of painting: Collection Concordia University–Portland.

Reflections, Lake McBride
Elmer Stanley Hader,
Karn's Farm, West Shokan, New York, 1952.
Oil on canvas board, 18" x 24".
Photo of painting: Collection Concordia
University–Portland.

Below: Paintings of the same apple
orchard from different points of view,
in four different seasons.

Shokan Spring
Elmer Stanley Hader, West Shokan, New York, 1956.
Oil on canvas board, 18" x 24".
Photo of painting: Collection Concordia University–Portland.

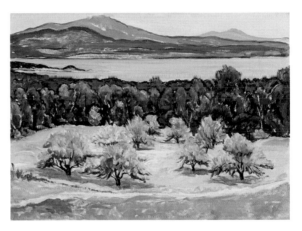

Apple Trees in September
Elmer Stanley Hader, West Shokan, New York, 1954.
Oil on canvas board, 18" x 24".
Photo of painting: Collection Concordia University–Portland.

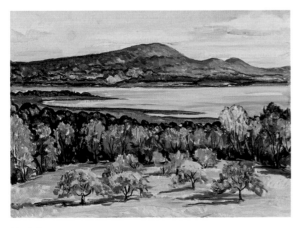

The Lake
Elmer Stanley Hader, West Shokan, New York, 1954.
Oil on canvas board, 18" x 24".
Photo of painting: Collection Concordia University–Portland.

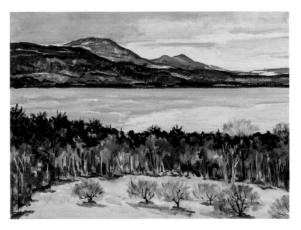

Winter in the New Year
Elmer Stanley Hader, West Shokan, New York, 1956.
Oil on canvas board, 18" x 24".
Photo of painting: Collection Concordia University–Portland.

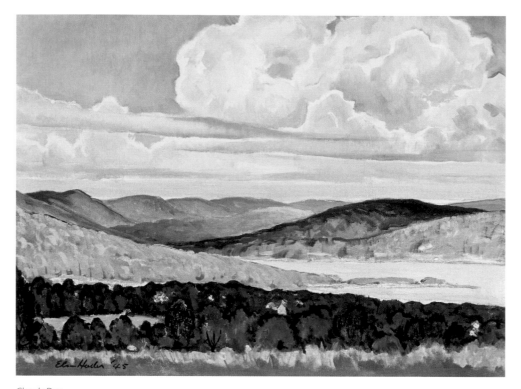

Cloudy Day
Elmer Stanley Hader, West Shokan, New York, 1945.
Oil on canvas board, 18" x 24".
Photo of painting: Collection Concordia University–Portland.

Elmer's dramatic skies (this page and facing page).

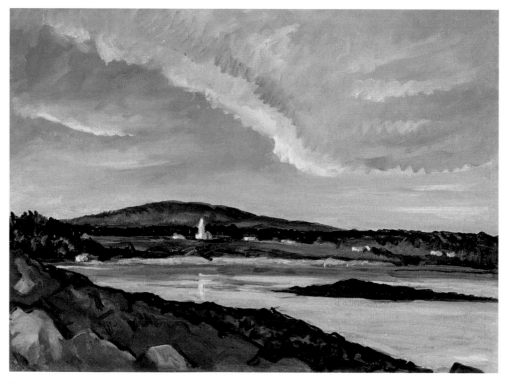

Summer Evening at Goose Cove
Elmer Stanley Hader, Goose Cove, West Tremont, Maine, 1945.
Oil on canvas board, 18" x 24".
Photo of painting: Collection Concordia University–Portland.

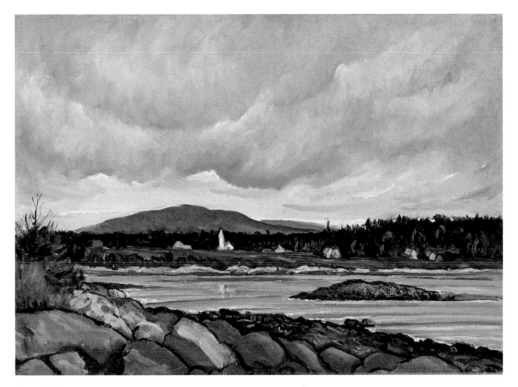

Tranquil Day
Elmer Stanley Hader, Goose Cove, West Tremont, Maine, 1945.
Oil on canvas board, 18" x 24".
Photo of painting: Collection Concordia University Portland.

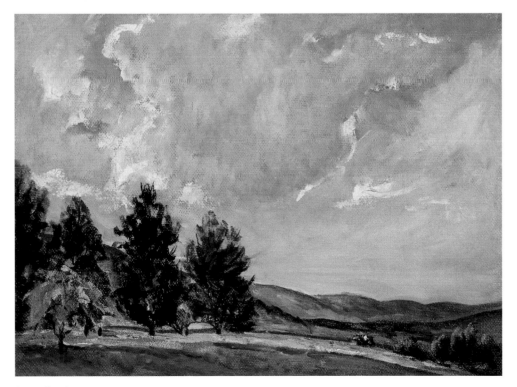

Storm Clouds
Elmer Stanley Hader, West Shokan, New York, 1957.
Oil on board, 18" x 24".
Photo of painting: Collection Concordia University–Portland.

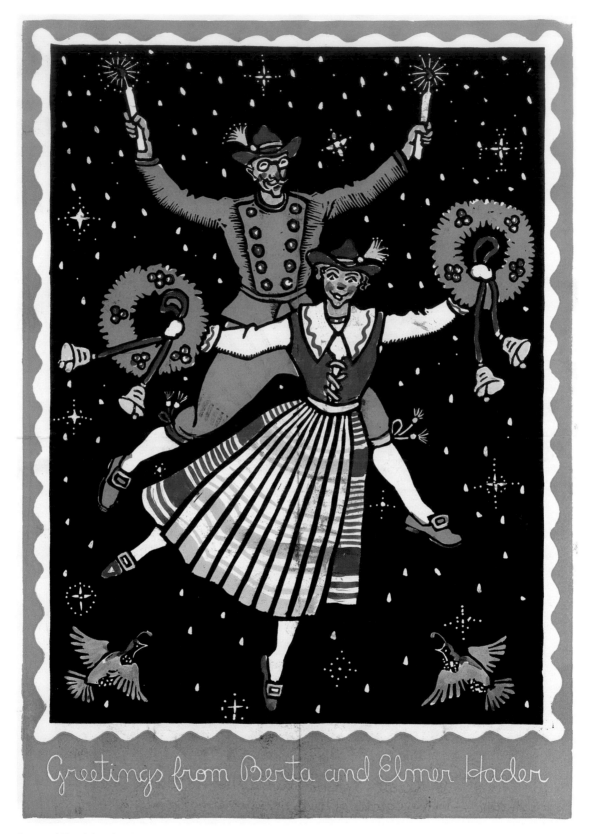

Berta and Elmer's handmade Christmas card, 1970.
Linoleum block print in black and green; other colors hand-painted with watercolor.
Scanned from original print. Collection Concordia University–Portland.

11
Christmas Tradition

Very early in their marriage, the Haders started a tradition that was to continue for their entire lives. They created their own unique Christmas cards each year and mailed them to friends and family. The first card (1921) was drawn in black India ink and entirely hand colored with watercolor; subsequent cards were created as linoleum block prints, each of which was colored with watercolor. The first card was small, about seven inches square, and depicted Mother Mary and Baby Jesus. In the first few years, the size of the card was variable. Their mailing list was a long one, and included friends, family, acquaintances, and colleagues in their book world.

The Haders approached the creation of their cards in much the same way they approached creating a book. They would imagine a variety of possibilities and show idea sketches to one another, then draw one or more of those idea sketches in larger format. They would share thoughts and make adjustments until they were both satisfied with the result. The graphically pleasing style they used for these designs was similar to the artistic style used in some of their early successful book illustrations.

Once their design was final, they would then carve the design into the surface of a piece of linoleum adhered to a block of wood. This was carefully inked and pressed onto 12" x 18" pieces of paper, creating prints in either black and green or black and red. Each color of ink had to be printed separately. These poster-sized cards were individualized by adding additional color by hand in watercolor and by writing a personal note to the recipient on the back, making each one unique. After adding their written greetings, typically signed "With oceans of love, Bertanelmer," they then folded the cards twice, placed them in homemade envelopes, addressed them, and mailed them near and far. In 1950 their Christmas card mailing list totaled 365.

After the first year, the cards reflected events in their lives. They would draw caricatures of themselves in front of their fireplace or as rag-doll ornaments hanging on a Christmas tree. As their career as book writers and illustrators developed, so did the themes of the annual cards. Beginning in 1933, the annual cards incorporated images from the Hader book(s) being released that holiday season. Little White Foot, Squirrely, Whiffy McMann, lions and tigers and elephants too all took their turns appearing on a Hader Christmas Card. Though the supporting characters were different each year, Berta and Elmer appeared on nearly all of the cards. *Two is Company, Three's a Crowd* was their

last published book, and the geese from that book appeared with them on the 1964 card. The next eight cards depicted Berta and Elmer in a variety of whimsical settings and outfits.

The card of 1973 showed only two deer looking up at the Little Stone House and a bright yellow star above the house. That was the year that Elmer died. The following year depicted two frolicking reindeer. The final card (1975) showed a smiling angel above Willow Hill. Berta passed away in February of 1976.

Berta and Elmer's first handmade Christmas card, 1921.
Pen and ink with watercolor.
Scanned from original print.
Collection Concordia University–Portland.

Berta and Elmer's handmade Christmas card, 1924.
Linoleum block print in black, with hand-painted watercolor.
Scanned from original print.
Collection Concordia University–Portland.

Berta and Elmer's handmade Christmas card, 1928.
Linoleum block print in black, with hand-painted watercolor.
Scanned from original print. Collection Concordia University–Portland.

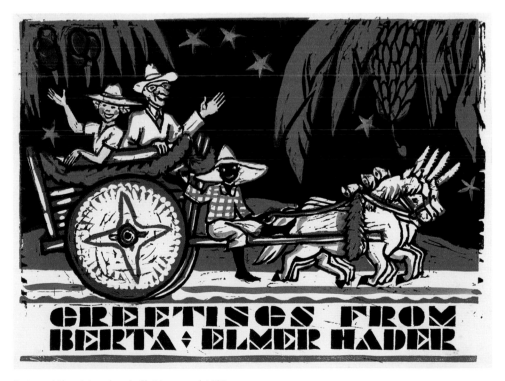

Berta and Elmer's handmade Christmas card, 1935.
Theme: *Jamaica Johnny*.
Linoleum block print in black, green, and red, with hand-painted watercolor.
Scanned from original print. Collection Concordia University–Portland.

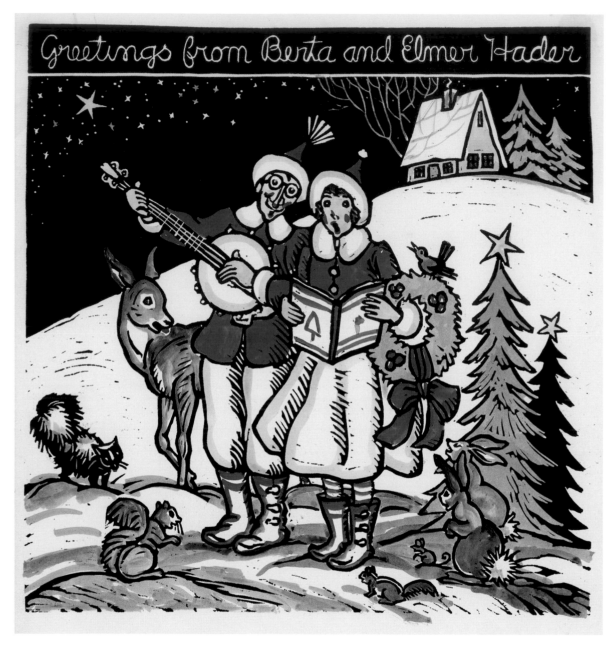

Greetings from Berta and Elmer Hader

Berta and Elmer's handmade Christmas card, 1944.
Theme: *The Little Stone House*.
Linoleum block print in black only, with all colors hand-painted in watercolor.
Scanned from original print.
Collection Concordia University–Portland.

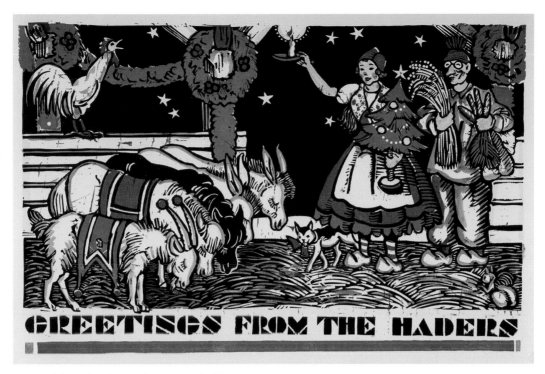

Berta and Elmer's handmade Christmas card, 1939.
Theme: *Cock-a-Doodle-Do*, with visiting characters from other Hader books.
Linoleum block print in black, red, and green, with hand-painted watercolor.
Scanned from original print. Collection Concordia University–Portland.

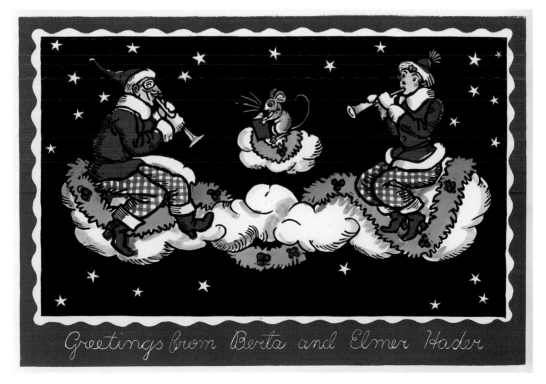

Berta and Elmer's handmade Christmas card, 1952.
Theme: *Little White Foot*.
Linoleum block print in black and red, with hand-painted watercolor.
Scanned from original print. Collection Concordia University–Portland.

Linoleum block, designed and hand-carved by the Haders, used to print their 1958 Christmas card. Theme: *Little Chip of Willow Hill*. Collection Concordia University–Portland.

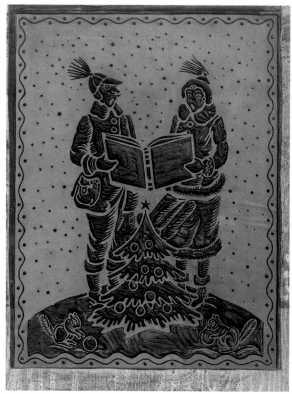

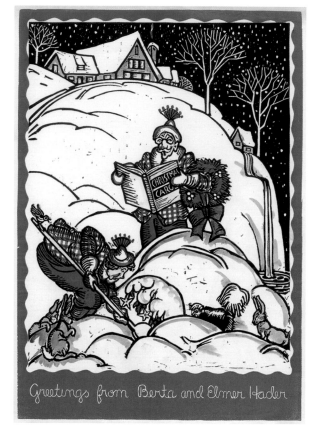

Berta and Elmer's handmade Christmas card, 1948. Theme: *The Big Snow*. Linoleum block print in black and green, with hand-painted watercolor. Scanned from original print. Collection Concordia University–Portland.

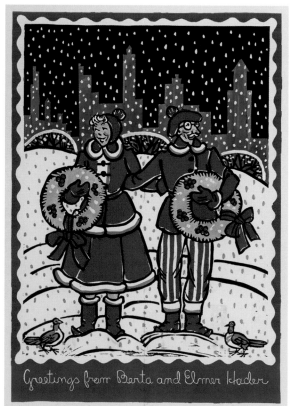

Berta and Elmer's handmade Christmas card, 1963. Theme: *Snow in the City*. Linoleum block print in black and red, with hand-painted watercolor. Scanned from original print. Collection Concordia University–Portland.

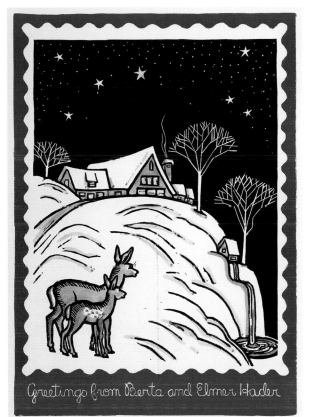

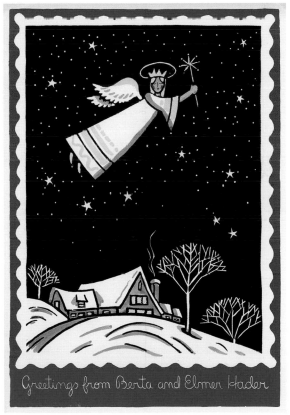

Berta and Elmer's handmade Christmas card, 1973.
Elmer died this year, but Berta continued the tradition for
two more years.
Linoleum block print in black and red, with hand-painted
watercolor.
Scanned from original print.
Collection Concordia University–Portland.

The last Hader handmade Christmas card, 1975.
Linoleum block print in black and red, with
hand-painted watercolor.
Scanned from original print.
Collection Concordia University–Portland.

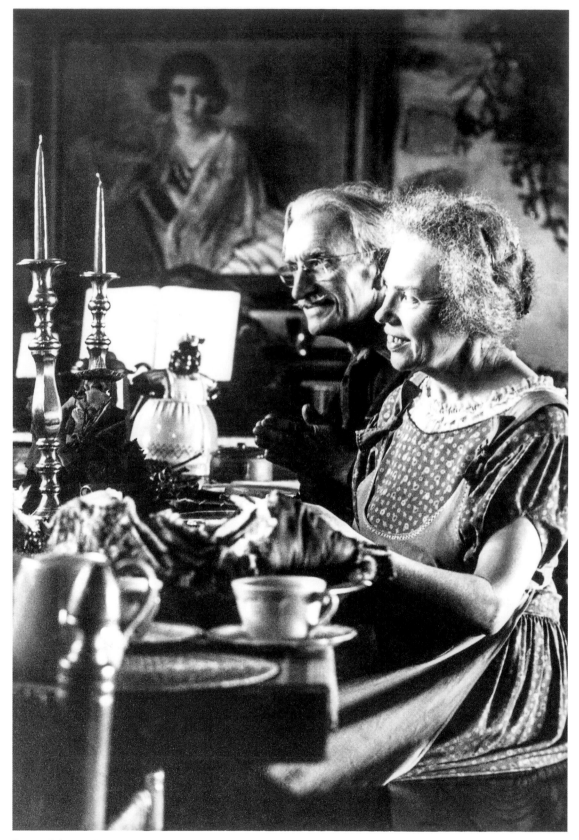

Berta and Elmer in their home at Willow Hill, 1970.
Photographer unknown. Collection Concordia University–Portland.

Afterword

Elmer became less robust the last few years of his life, but he remained full of ideas and merriment, quick to smile as always. He was able to stay home with Berta until just the last few weeks he was alive. He went into a care home, but there too, Berta remained at his side. On the last day of Elmer's life Berta asked him what he was thinking and he said, "That I've been damn lucky." Shortly after his death Berta told friends and colleagues that she did not wish readers to know of Elmer's death, for she knew it was their books that would live on.

Berta stayed at the Little Stone House following Elmer's death, where she wrote letters to friends and cared for the animals of Willow Hill. A wild white bunny came to visit her on the patio regularly. The last six weeks of her life were spent with her nephew, Richard, and his family. In a letter written just days before she died, she told a friend that, being cared for by Richard and his wife, she felt like she was in Heaven already.

Records were not kept of the total number of Hader books printed. Many of their titles were reprinted more than a dozen times. *The Big Snow* has been in print continuously since 1948. It is currently in its forty-fourth printing. Some of their books were translated into Hebrew, Italian, Portuguese, Danish, Spanish, French, Norwegian, Hindi, Urdu, Czech, and Korean. These two fine people lost their only child, but they gently and beautifully touched the lives of millions of other children.

Throughout their lives, Berta and Elmer contributed artwork to fundraisers and worthy causes. They also answered the call when universities were dedicating themselves to collecting the working files of children's writers and illustrators so that future researchers could appreciate and understand their creative processes. When Dr. Irvin Kerlan of the University of Minnesota requested Hader items for their Children's Literature Special Collections, the Haders donated a significant amount of original material. When Dr. Lena deGrummond of the University of Southern Mississippi sought to begin a Special Collection of Children's Literature at her university, the Haders were the first to contribute. When Ed Kemp knocked on their door for the first time it was, according to Ed, love at first sight, and it was mutual. The Haders entrusted the bulk of their creative materials to Mr. Kemp for the Special Collection at the University of Oregon.

The Haders' senses of humor outlived them as well. Early in this century a man who had

grown up admiring the Little Stone House, Mark Goldstein, bought it. He recognized that it needed major renovation. A worker on the roof stepped on a weak spot and fell through. He landed in a hidden chamber, a small closet-type area that had no doors or windows. Inside, hidden away, were original art boards, original sketch-a-minute type paintings, carved linoleum blocks for the Christmas cards, correspondence, and more. This find was a surprising treat and a total mystery. Why had these items been secreted away? One can easily imagine the Haders, especially Elmer, quietly chuckling as those of us left behind scratch our heads in wonderment.

After Berta and Elmer's deaths, ten of their books were republished in the 1980s and 1990s. There have been exhibits of some of Elmer's paintings on both the East and West coasts. Exhibits, full of original art for the magazine pages of the 1920s, their Christmas cards and interesting ephemera tucked away by pack rat Berta, held in dozens of venues, have offered a tantalizing glimpse into their creative processes, the elegance and beauty of their work, and their lives. A nonprofit organization was founded in 2008, Hader Connection, Ltd., which is dedicated to reintroducing the Haders. The nonprofit has arranged exhibits, conducted presentations, created a web site showcasing examples of the Haders' work, and taken a whimsical art lesson based on Hader caricature maps of the states into third and fourth grade classrooms.

This charming, sensitive, talented couple led an exemplary life of working together as one, working hard, playing joyfully with friends they loved, and respecting and caring for the land and creatures that surrounded their unique and friendly home. They left a lasting legacy of love, gentle humor, captivating and instructive children's stories, and exquisite artwork.

Glossary

Art board. Panel upon which an illustration is laid out and rendered, usually stiff illustration board with a surface that will accept fine ink linework and water-based paint.

Board. Panel of wood, usually primed to accept oil paints and prevent chemicals in the wood from leaching into the painting.

Block print. Art print made from a block of wood or other suitable material. A design is cut into the block surface with a knife or gouge, with the raised (uncarved) areas representing a mirror image of the parts to show printed. The carved surface is inked with a roller and then impressed onto paper or fabric. The actual printing can be done by hand or with a press (see also Linoleum print, below).

Cameo. A brief, often inconspicuous appearance of a known person (often the author) in a work of art, theater, or literature, typically unnamed or appearing as him/herself in character with the theme of the work.

Canvas board. Heavy cardboard with cotton or linen canvas glued to the surface, with the edges folded over to the back, primed to accept oil paints.

Caricature. A simple image showing its subject's features in a simplified or exaggerated way.

Color overlays. Transparent overlays specifying the application of color inks to the key plate (see below), usually registered (see below) by means of cross-hair register marks applied to the key plate and all overlays.

Colored pencil. Drawing pencil with colored lead consisting of colored chalk or crayon bound in the usual cylindrical or hexagonal case of wood.

Dummy. A preliminary mockup of a book: a page-by-page layout made to the exact size of the proposed work and showing the location of display and body type and the positions of illustrations. A dummy can also be a series of rough sketches, conceptualizing and developing the project.

Dummy drawing. Copy of artist's key line drawing (see below) with color applied by the artist in paint or colored pencil to specify application of color for separations in printing. This is used as a guide when the printer, rather than the artist, creates the final color overlays (see above) for printing.

Eucalyptus. Species of tree, introduced from Australia, commonly growing on the open hills of San Francisco in the early twentieth century. Large specimens can still be seen in undeveloped areas such as Golden Gate Park and the San Francisco Zoo.

Gouache. (Pronounced "gwash.") A heavier, more opaque form of watercolor paint. Whites in a gouache painting are applied with opaque white paint, whereas in transparent watercolor painting, whites are achieved by leaving the white of the paper unpainted. Gouache was a popular medium among early- and mid-twentieth-century illustrators.

Graphite pencil. Drawing pencil with "lead" made from graphite (a greasy form of carbon) mixed with clay. Higher clay content makes a harder lead. Graphite pencils make a shiny, gray mark and are graded from 6B (softest) to HB (medium) to 9H (hardest) Soft leads make darker marks, and hard leads make lighter marks.

Halftone. A printing technique that simulates continuous-tone imagery by the use of tiny dots which vary in size or spacing, set in a specific pattern. In the days of Berta and Elmer's work the artwork was photographed through a screen with a process camera. Identical photographs were taken for each color to be used in the final printing, and the screen was rotated each time at a specific angle, which resulted in the dot patterns on the film. (In modern times the screen is imposed digitally. Most books today are set at a resolution of 300 DPI, which means there are 300 dots per inch, regardless of their size.) Four inks are generally used in this process: cyan, magenta, yellow, and black (CMYK), and the intensity of the colors is determined by the size and spacing of the dots. The inks are semi-opaque, and since the various color dots overlap each other slightly, in an optical illusion, the human eye sees the dots as smooth tones in the printed image. The term "halftone" can also refer to an image that is produced by this process.

Impasto. Painting technique where paint is laid very thickly on the surface so that brush strokes stand out in relief and are prominently visible, contributing to the "mood" and sense of motion in a painting. This technique was and is still popular with impressionist painters (see below).

Impressionism. A 19th-century art movement that originated with a group of Paris-based artists. Impressionist painting characteristics include relatively small, thin, yet visible brush strokes; open composition; emphasis on accurate depiction of light in its changing qualities; common, ordinary subject matter; inclusion of movement as a crucial element of human perception and experience; and unusual visual angles. Impressionism is still popular among artists today. The impressionist painter strives to portray an emotional response to a scene or subject, rather than a photorealistic depiction.

Ivory. Material used for carving and as a ground for painting, taken from the tusk of an elephant, walrus, or hippopottamus. For painting, thin sections are shaved off an elephant tusk, bleached with hydrogen peroxide if necessary, and placed in the sun to whiten. The surface is roughened slightly with emery paper, pumice, or cuttlebone to prepare it for painting, and it must be clean and free from fingerprints in order to accept the paint, usually gouache (see above).

Key drawing. Artist's drawing for the key plate (see below), usually consisting of linework and flat black areas and printed in black ink, to which the color inks will be registered (see below) in printing.

Key line. Linework in the key plate (see below), usually printed in black, against which the color inks will be registered (see below). See also Color overlays.

Key plate. When printing color images by combining multiple colors of inks, the colored inks usually do not contain much image detail. The key plate, which is usually impressed using black ink, provides the lines and/or contrast of the image.

Lantern slide. A glass slide with an image printed on it, used in an early form of image projector called a magic lantern.

Linoleum print. Art print made with a printmaking technique called linocut, a variant of woodcut, in which a sheet of linoleum (sometimes mounted on a wooden block) is used for the relief surface. A design is cut into the linoleum surface with a knife or gouge, with the raised (uncarved) areas representing a mirror image of the parts to show printed. The linoleum sheet is inked with a roller and then impressed onto paper or fabric. The actual printing can be done by hand or with a press.

Lithographic plate. Originally in lithography ("writing on stone"), an image was created on a flat, smooth slab of limestone with an oily ink that was absorbed into the stone. The stone was then coated with a solution containing acid which "fixed" the oil in the stone and, when dry, the residue was washed off the stone. In printing, the entire surface was wet; the fixed design areas repelled water but accepted a greasy ink. A sheet of paper was pressed against the surface, and the stone and paper together were run through a press, creating a reverse of the original image. In color lithography, a separate stone or plate was used for each color of ink employed. Ink colors could be combined during printing by impressing the same area with two or more different inks.

In modern times, flexible aluminum, polyester, mylar, or paper plates are used in place of stone in a variant of this process called **offset lithography,** which depends on photographic processes (printers of the Haders' books used this process). The surface of the plate has a roughened texture and is coated with a photosensitive emulsion. A photographic negative of the original image is placed in contact with the emulsion and the plate is exposed to ultraviolet light. After developing, a reverse of the negative image is revealed, which is a duplicate of the original image. Non-image portions of the emulsion are chemically removed and the plate is affixed to a cylinder on the printing press and dampened and inked in much the same way as in the original process. If this image was transferred directly to paper, the result would be a mirror image of the original, so the plate rolls against a cylinder covered with a rubber blanket, which absorbs the ink from the plate and transfers it as a positive image to the paper, which is pressed between the blanket and an impression cylinder. Present-day advances in technology have changed the process again and eliminated the need for physical plates in computer-to-plate printing.

Masonite. Stiff panel made of pressed and hardened cellulose (wood) fibers, usually primed to accept oil paints and prevent chemicals in the panel from leaching into the painting.

Nom de plume. A pen name or pseudonym adopted by an author.

Pastels. Pastel sticks or crayons consisting of pure powdered pigment combined with a binder. The texture is chalk-like. Pastels are available in a wide range of shades and tints, and are applied by drawing directly on the surface, usually a sandy-textured paper. Colors are mixed right on the painting as they are applied, at the artist's discretion.

Plein air. French term meaning "open air," "on location." Impressionist painters, especially, painted *"en plein air"* with portable supplies in order to capture their subjects in natural light.

Quill pen. A writing or drawing instrument made from a moulted flight feather (quill) from a large bird. The tip of the quill is carefully sharpened into a slit point, and the hollow shaft of the feather provides a reservoir for the ink which flows out through the tip via capillary action. The tip is very durable and, with more flexibility than a steel pen, produces an inimitably sharp stroke. This flexibility allows the artist a wide range in the quality and character of his or her linework.

Registration. In printing, matching transparent overlays specifying the overprinting of color inks (see above) to the key plate, usually by means of cross-hair register marks applied to the key plate and all overlays.

Signature. A single large folded sheet of paper upon which pages are arranged in multiples of four and printed, front side and back, comprising a section of a printed book. The pages must be arranged (called the "imposition") so that when the signature is printed, folded, and cut, the pages will fall in the proper sequence in the book.

Solander case. A large, flat, sturdy box made of wood or paper board, used for safely storing maps, manuscripts, prints, documents, etc.

Tearsheet. A page torn or cut from a published book or magazine as proof of publication or as a sample of the appearance of a final illustration or advertisement.

Value. Range of tones (darks and lights) used in a work of art to produce an illusion of atmosphere, mood, and dimensionality.

Vaudeville. A theatrical genre of variety entertainment popular in the United States and Canada from the early 1880s until the early 1930s. Each performance was made up of a series of separate, unrelated acts grouped together on a common bill. Types of acts included popular and classical musicians, dancers, comedians, trained animals, magicians, female and male impersonators, acrobats, illustrated songs, jugglers, one-act plays or scenes from plays, athletes, lecturing celebrities, minstrels, and movies.

References, Credits, and Notes

Note: The reader will encounter reference numbers within the text that refer to this References, Credits, and Notes section. We have combined our cited references and bibliography into the following numbered list, arranged alphabetically. The reference numbers in the text refer to the items on this list with the corresponding numbers.

1. Anderson, William. "How the Little House Books Found a Publishing Home." *Language Arts* 58, no. 4 (April 1981): 437–440.
2. "Artists Build Own Home." *The Rocklander,* April 1931. (Author unknown.)
3. Barrow, Jane. Letter to Lynne Stuart, March 25, 1981. Private collection.
4. Bechtel, Louise Seaman. *Books in Search of Children.* New York: The Macmillan Company, 1969: 63–66, 163, 217, 248.
5. Bechtel, Louise Seaman. "Thinking About Children's Classics." *The Packet* 10, no. 2 (Fall 1955): 3–19.
6. Beman, Lynn S. *Elmer Stanley Hader (1889–1973): A Rediscovered American Impressionist; His Life and Paintings.* Unpublished. August 1, 1989.
7. "Berta and Elmer Hader." *The Instructor,* November, 1951: 10–12. (Author unknown).
8. "Berta and Elmer Hader: Makers of the Picture Book of Mother Goose." *Nyack New York Journal,* 1935. (Author unknown.)
9. Blanshard, Julia. "They're Married to Their Art—Husband and Wife Together Achieve Fame as Illustrators." *New York Tribune,* November 26, 1929.
10. Carroll, Latrobe. Letter to Richard Horner (*né* Hoerner). March 24, 1981. Private collection.
11. deRegniers, Beatrice (Scholastic Book Services, Lucky Book Club). Letter to Berta and Elmer Hader, December 5, 1963. *Collection U of O, AX441 (Addenda), Box 3, Folder: S.
12. Dobbs, Rose. "Personality into Books: Berta and Elmer Hader." *The Horn Book Magazine,* November, 1949: 509-517.
13. Glick, M. B. (The Viking Press). Letters to Elmer Hader. November 17, 1938, November 30, 1938, December 7, 1938. *Collection U of O, AX441 (Addenda), Box 3, Folder: Viking.

14. Gordon, Adelaide. Letter to Berta Hoerner. c. 1915. *Collection U of O, AX441 (Addenda), Box 1, Folder: Gordon, Adelaide 1915–1918.

15. Gordon, Adelaide and William. Letter to Berta Hoerner. c. 1915. *Collection U of O, AX441 (Addenda), Box 1, Folder: Gordon, Adelaide 1915–1918.

16. Griffis, Enid. "Artists Grin at Temperament" (draft). *Brooklyn Eagle Magazine,* November 10, 1929: 1–6. Private collection.

17. Hader, Berta and Elmer. *Berta and Elmer Hader* (four-page pamphlet). New York: The Macmillan Company, January, 1969. Private collection.

18. Hader, Berta and Elmer. Biographical sketches provided to Irvin Kerlan. August 24, 1956. *Collection U of O, AX441 (Addenda), Box 4, Folder: Kerlan, Irwin.

19. Hader, Berta. Letter to Miss Ada M. Randall. 1937. *Collection U of O, AX441 (Addenda), Box 3, Folder: Randall, Ada.

20. Hader, Berta. Letter to Roger MacBride. July 18, 1972. *Collection U of O, AX441 (Addenda), Box 3, Folder: Laura Ingalls Wilder Memorial Society 1972–1975 (filed under W).

21. Hader, Berta. Letter to William Anderson. April 21, 1972. *Collection U of O, AX441 (Addenda), Box 3, Folder: Laura Ingalls Wilder Memorial Society 1972–1975 (filed under W).

22. Hader, Berta and Elmer. *All's Well That Ends Well; a Story Without Words.* Unpublished, Undated. Vassar College (Louise Seaman Bechtel Collection).

23. Hader, Berta and Elmer. Caldecott Acceptance Paper. *The Horn Book Magazine,* November, 1949: 500–508.

24. Hader, Berta and Elmer. *Home is the Goal—An Idyl on the Hudson. Home Sweet Home.* Unpublished, 1947. Private collection.

25. Hader, Berta and Elmer. Letter to Anne Diven (The Macmillan Company). July 22, 1961. *Collection U of O, AX441 (Addenda), Box 3, Folder: Macmillan Publishing Co. (1963–1965).

26. Hader, Berta and Elmer. Letter to Hattie Bell Allen. August 12, 1955. *Collection U of O, AX441 (Addenda), Box 3, Folder: A.

27. Hader, Berta and Elmer. Letter to Doris Patee (The Macmillan Company). April 1, 1940. *Collection U of O, AX441 (Addenda), Box 3, Folder: Patee, Doris.

28. Hader, Berta and Elmer. Letter to Doris Patee (The Macmillan Company). February 12, 1944. *Collection U of O, AX441 (Addenda), Box 3, Folder: Patee, Doris.

29. Hader, Berta and Elmer. Letter to Jeremiah Kaplan, Executive Vice President of The Macmillan Company. November 30, 1962. *Collection U of O, AX441 (Addenda), Box 3, Folder: Macmillan Publishing Co. (1956–1962).

30. Hader, Berta and Elmer. Letter to Lois Sullivan (Great Neck Public Schools). December 3, 1936. *Collection U of O, AX441 (Addenda), Box 3, Folder: S.

31. Hader, Berta and Elmer. Letter to Louise Seaman Bechtel. Undated. *Collection U of O, AX441 (Addenda), Box 1, Folder: Bechtel, Louise (Seaman).

32. Hader, Berta and Elmer. Letter to Marian Webb. March 27, 1964. Private collection.

33. Hader, Berta and Elmer. *On Illustrating Picture Books for Children* (typed rough draft). Undated. Private collection.

34. Hader, Berta and Elmer. "The Picture Book World: A Few Thoughts on the Subject." *School and Home* 15, no. 54 (January–March, 1933): 101–104.

35. Hader, Elmer Stanley. *An Interview in the Mirror.* Unpublished essay. *Collection U of O, AX441 (Addenda), Box 6, Folder: Biographical Data.

36. Hader, Elmer. Letter to Anne Harris. April 29, 1970. *Collection U of O, AX441 (Addenda), Box 2, Folder: Harris, Anne B.

37. Hader, Elmer. Letter to Berta. December 28, 1917. *Collection U of O, AX441 (Addenda), Box 2, Folder: Hader, Elmer.

38. Hader, Elmer. Letter to Mr. McCann (Coward-McCann). June 8, 1930. *Collection U of O, AX441 (Addenda), Box 1, Folder: Coward-McCann.

39. "Haders Describe How They Write Books for Children at Civic League Luncheon." *Nyack New York Journal,* 1936. (Author unknown.)

40. Hall, Barbara (The Macmillan Company Juvenile Department). Letter to Berta and Elmer Hader. October 5, 1948. *Collection U of O, AX441 (Addenda), Box 3, Folder: Macmillan Publishing Co. (1942–1951).

41. Holtz, William. *The Ghost in the Little House.* Columbia: University Missouri Press, 1993: 71, 80–92.

42. Homann, Joan Marie. *Magazine Paper Dolls…a Chronology.* Texas: Joan Homann, 1996: 28, 73–75, 100.

43. Hopkins, Lee Bennett. *Books are by People.* New York: Citation Press, 1969: 98–102.

44. Keene, Frances (The Macmillan Company). Letter to Berta and Elmer Hader. October 11, 1963. *Collection U of O, AX441 (Addenda), Box 3, Folder: Macmillan Publishing Co. (1963–1965).

45. Kemp, Elaine and Edward. "Berta and Elmer Hader of Willow Hill." *Imprint Oregon,* University of Oregon Library, 1977: 4–11.

46. Kemp, Elaine and Edward. *We Remember Berta and Elmer Hader.* Unpublished, January 27, 2009. Private collection.

47. Lacy, Lyn Ellen. *Art Design in Children's Picture Books; An Analysis of Caldecott Award Winning Illustrations.* Chicago and London: American Library Association. 1986: 144–147; 158–161.

48. Lane, Rose Wilder. "Artist Brings Out Beauties of Landmark." *San Francisco Bulletin,* November 28, 1917.

49. Lane, Rose Wilder. Letter to Berta and Elmer Hader. November 25, 1925. *Collection U of O, AX441 (Addenda), Box 2, Folder: Lane, Rose Wilder.

50. Lane, Rose Wilder. Letter to Dorothy Thompson. November 18, 1960. *Collection U of O, AX441 (Addenda), Box 2, Folder: Lane, Rose Wilder.

51. Lee, Bill. *Berta and Elmer Hader and Their Beloved Little Stone House: A Collection of Memories.* Published electronically: *The Haders—and Their House.* 2004.

52. Mathias, Fred. *Grand-View-on-Hudson: A History* (second edition by Betty M. Geist). 1959: 24–25.

53. McBride, Mary Margaret. *A Long Way From Missouri.* New York: G.P. Putnam's Sons, 1959: 131–138.

54. McBride, Mary Margaret. "Elmer and Berta Hader, Winners of the Caldecott Medal." *Publishers Weekly,* March 26, 1949: 1412–1415.

55. McBride, Mary Margaret. *Out of the Air.* New York: Doubleday & Co., 1960: 102–105.

56. Miller, Bertha M. "Caldecott Medal Books, 1938–1957." *The Horn Book Magazine,* 1957. *Collection U of O, AX441 (Addenda), Box 2, Folder: Bertha Mahoney.

57. Partridge, Roi. Letter written to Richard Horner (*né* Hoerner). February 26, 1981. Private collection.

58. Patee, Doris. "Berta and Elmer Hader Working Together." *Imprint Oregon,* University of Oregon Library, 1977: 2–3.

59. Patee, Doris (The Macmillan Company). Letter to Berta and Elmer Hader. September 24, 1947. *Collection U of O, AX441 (Addenda), Box 3, Folder: Macmillan Publishing Co. (1942–1951).

60. Patee, Doris (The Macmillan Company). Letter to Berta and Elmer Hader. October 5, 1948. *Collection U of O, AX441 (Addenda), Box 3, Folder: Macmillan Publishing Co. (1942–1951).

61. Patee, Doris (The Macmillan Company). Letter to Elmer Hader. December 31, 1935. *Collection U of O, AX441 (Addenda), Box 3, Folder: Macmillan Publishing Co. (1935–1941).

62. Patee, Doris (The Macmillan Company). Letter to Mary Margaret McBride. March 1, 1949. *Collection U of O, AX441 (Addenda), Box 3, Folder: McBride, Mary M.

63. Paterson, Virginia H. (The Macmillan Company). Letter to Berta and Elmer Hader. March 14, 1950. *Collection U of O, AX441 (Addenda), Box 3, Folder: Macmillan Publishing Co. (1942–1951).

64. *Reflections.* One page rough draft (author unknown). Undated. Private collection.

65. Russell, John. "An Art School That Also Taught Life." *New York Times,* March 19, 1989.

66. Seaman, Louise. Berta and Elmer and Their Picture Books, in The Bookshop for Boys and Girls, *The Horn Book Magazine,* August 1928: 52–57.

67. Smaridge, Norah. *Famous Literary Teams for Young People.* New York: Dodd, Mead and Company, 1977: 41–48.

68. Stringer, Charles. Letter to Elmer Hader. January 22, 1930. *Collection U of O, AX441 (Addenda), Box 3, Folder: Stringer, Charles.

69. Taber, Louise E. *The Work of Elmer Stanley Hader: An Appreciation.* San Francisco: Palace of Fine Arts, 1917.

70. Varian, Jane. Letter to Berta and Elmer Hader. April 28, 1944. *Collection U of O, AX441 (Addenda), Box 3, Folder: U V W.

71. Weil, Elsie. Letter to Berta Hader. August 10, 1926. *Collection U of O, AX441 (Addenda), Box 3, Folder: Weil, Elsie.

72. White, Dorothy Neal. *About Books For Children.* New Zealand Council for Educational Research, 1946: 15, 40–41, 79.

73. Wilder, Laura Ingalls. *West From Home.* New York: Harper & Row, 1974: 79.

74. Young, Mary. *A Collector's Guide to Magazine Paper Dolls.* Collector Books, 1990.

*University of Oregon, Knight Library Special Collections, Berta and Elmer Hader

Note: Images from *The Big Snow* by Berta and Elmer Hader reprinted with the permission of Simon & Schuster Books for Young Readers, an imprint of Simon & Schuster Children's Publishing Division, Copyright 1948 Berta and Elmer Hader; copyright renewed © 1976 Berta Hader.

Credits for Illustrations without Captions

Front Cover: Cover art from Hader, Berta and Elmer. *Working Together: the Inside Story of the Hader Books.* New York: The Macmillan Company, 1937. Scanned from printed book.

Front Cover inside flap: Andersen, Hans Christian, *The Ugly Duckling.* Happy Hour edition illustrated by Berta and Elmer Hader. New York: The Macmillan Company, 1927. Scanned from printed book.

Back Cover: Haders' illustrated letter to editor Doris Patee regarding *Cricket.* Scanned from original. *Collection U of O, AX441, Box 1, Correspondence, Outgoing, Patee binder.

Half title: Unique dedicatory watercolor art from a copy of *Mister Billy's Gun,* by Berta and Elmer Hader. New York: The Macmillan Company, 1960. Scanned from original. Private collection.

Title: Top panel from "Katrinka, the Little Russian." *Good Housekeeping Magazine,* December, 1924. Scanned from original art board. Collection Concordia University–Portland.

Dedication: Unique dedicatory watercolor art from a copy of *Berta and Elmer Hader's Picture Book of Mother Goose,* by Berta and Elmer Hader. New York: Coward-McCann, 1930. Scanned from original. Private collection.

Contents: Hader, Berta and Elmer. *Berta and Elmer Hader's Picture Book of Mother Goose.* New York: Coward-McCann, 1930. Scanned from printed book. Private collection.

Foreword: Pen and ink art likely produced for *Asia* magazine. Scanned from original art board. Collection Concordia University–Portland.

Preface: Meigs, Cornelia, Illustrated by Berta and Elmer Hader. *The Wonderful Locomotive.* New York: The Macmillan Company, 1928.

Introduction: Hader, Berta and Elmer. *Berta and Elmer Hader's Picture Book of Mother Goose.* New York: Coward-McCann, 1930. Scanned from printed book. Private collection.

Opening Chapter 1: Pen and ink art with watercolor on illustrated personal letter from Berta (recipient and date unknown). Scanned from original. Collection Concordia University–Portland.

Opening Chapter 2: *Concarneau Fisherman.* Elmer Stanley Hader, France, 1913. Oil on canvas, 36" x 53½". Photo of painting: Collection Concordia University–Portland.

Opening Chapter 3: Section of *The Studios, Telegraph Hill.* Elmer Stanley Hader, San Francisco, 1917. Oil on canvas, 24" x 18". Photo of painting: Collection Concordia University–Portland.

Opening Chapter 4: Berta and Elmer Hader. *The Little Stone House: A Story of Building a House in the Country.* New York: The Macmillan Company, 1944. Scanned from original art board. *Collection U of O, AX441, SC 10.

Opening Chapter 5: Berta and Elmer Hader. *Two Funny Clowns.* New York: Coward-McCann, 1929. Scanned from printer's proof. Collection Concordia University–Portland.

Opening Chapter 6: Unique dedicatory watercolor art from a copy of *The Little Stone House: A Story of Building a House in the Country,* by Berta and Elmer Hader. New York: The Macmillan Company, 1944. Scanned from original. Private collection.

Opening Chapter 7: Caldecott Medal awarded to Berta and Elmer Hader in 1949 (front and back). *Collection U of O, AX441, Available for viewing upon request.

Opening Chapter 8: Berta and Elmer Hader. *Squirrely of Willow Hill.* New York: The Macmillan Company, 1948. Scanned from original art board. *Collection U of O, AX441, SC 20.

Opening Chapter 9: Berta and Elmer Hader. *Billy Butter.* New York: The Macmillan Company, 1936. Copyright page cameo. Scanned from original art board. *Collection U of O, AX441, SC 4.

Opening Chapter 10: *Old Apple Tree.* Elmer Stanley Hader, West Shokan, New York, 1943. Oil on canvas board, 18"x 24". Photo of painting: Collection Concordia University–Portland.

Opening Chapter 11: Berta and Elmer Hader. Illustrated letter to Doris Patee, December 20, 1944. Scanned from original. *Collection U of O, AX441, Box 1, Correspondence, Outgoing, Patee binder.

Afterword: Hader, Berta and Elmer. *Wish on the Moon.* New York: The Macmillan Company, 1954. Copyright page cameo. Scanned from original art board. *Collection U of O, AX441, SC 23.

End of Afterword: Berta and Elmer Hader. *Two Funny Clowns.* New York: Coward-McCann, 1929. Scanned from original art board. *Collection U of O, AX441, SC 23.

Glossary: Hader, Berta and Elmer. *Berta and Elmer Hader's Picture Book of Mother Goose.* NewYork: Coward-McCann, 1930. Scanned from printed book. Private collection.

References, Credits, and Notes: Hader, Berta and Elmer. *Berta and Elmer Hader's Picture Book of Mother Goose.* New York: Coward-McCann, 1930. Scanned from printed book. Private collection.

Chronological List of Hader Books: Berta and Elmer's personal bookplate (their own design). Private collection.

Acknowledgments: Meigs, Cornelia, Illustrated by Berta and Elmer Hader. *The Wonderful Locomotive.* New York: The Macmillan Company, 1928. Scanned from printed book. Private collection.

Note: Unless otherwise noted in captions, the current locations of Elmer Stanley Hader's paintings shown in this book are unknown. Photos of the paintings included herein were taken from Richard Horner's photographic record of the paintings created in 1986. (Richard was Berta Hoerner Hader's nephew.) Photo of *Winter, Little Falls,* page 29, provided by Russell Tether Fine Art, Dallas, TX.

Archives Housing Hader Materials

Concordia University, Portland, Oregon, University Libraries, Special Collections.
 Hader Collection: Original magazine art (paper dolls), original book art, dummies, illustrated letters, correspondence, Christmas cards, etc.

Emporia State University, Emporia, Kansas, University Libraries and Archives, Special Collections and Archives
 The May Massee Collection: dummies, books, illustrated letters, correspondence, etc.

The Historical Society of Rockland County, New City, New York.
 Hader books with dedicatory watercolors, Christmas cards, reviews, etc.

The Nyack Library, Nyack, New York
 Local History Department: photographs, correspondence, articles.

University of Florida, Gainesville, Florida, Baldwin Library of Historical Children's Literature.
 Louise Seaman Bechtel Collection: illustrated letters, Christmas cards, etc.

University of Minnesota, Minneapolis, Minnesota, Kerlan Collection, Children's Literature Research Collections.
 Hader Collection: Original book art, dummies, illustrated letters, correspondence, Christmas cards, etc.

University of Oregon, Eugene, Oregon, Knight Library, Special Collections.
 Hader Collection: Original book art, dummies, miniatures, illustrated letters, correspondence, Christmas cards, photographs, books, Caldecott Medal, etc.
 Jane Terrell Barrow Collection: Clippings, illustrated letters.

University of Southern Mississippi, Hattiesburg, Mississippi, deGrummond Children's Literature Collection.
 Hader Collection: Original book art, correspondence, books, Christmas cards, etc.

Vassar College, Poughkeepsie, New York, Catherine Pelton Durrell Archives and Special Collections Library.
 Louise Seaman Bechtel Collection: *All's Well That Ends Well,* correspondence, articles, reviews.

Wichita Public Library, Wichita, Kansas, Durst Decorative Arts Collection.
 Original cover art, original book illustrations, Christmas cards, etc.

Hader Books
(chronological list)

Note: All were illustrated by Berta and Elmer unless designated as Elmer alone (E)

Peedie, Jean Murdoch. *Donald in Numberland.* Rae D. Henkle Co., 1927.

Andersen, Hans Christian (special edition illustrated by Berta and Elmer). *The Ugly Duckling.* Happy Hour book. The Macmillan Company, 1927.

Grimm, Brothers (special edition illustrated by Berta and Elmer). *Hansel and Gretel.* Happy Hour book. The Macmillan Company, 1927.

Hader, Berta and Elmer. *Chicken Little and the Little Half Chick.* Happy Hour book. The Macmillan Company, 1927.

Hader, Berta and Elmer. *Wee Willie Winkie and Some Other Boys and Girls From Mother Goose.* The Macmillan Company, 1927.

McBride, Mary Margaret. *Charm: a Book About Those Who Have It and Those Who Want It.* Rae D. Henkle Co., 1927. (E)

Hader, Berta and Elmer. *The Little Red Hen.* Happy Hour book. The Macmillan Company, 1928.

Hader, Berta and Elmer. *The Old Woman and the Crooked Sixpence.* Happy Hour book. The Macmillan Company, 1928.

Hader, Berta and Elmer. *The Picture Book of Travel: The Story of Transportation.* The Macmillan Company, 1928.

Hader, Berta and Elmer. *The Story of the Three Bears.* Happy Hour book. The Macmillan Company, 1928.

Meigs, Cornelia. *The Wonderful Locomotive.* The Macmillan Company, 1928.

Emerson, Edwin. *Adventures of Theodore Roosevelt.* E.P. Dutton & Co., 1928. (E)

Hader, Berta and Elmer. *Two Funny Clowns.* Coward-McCann, 1929.

Williamson, Hamilton. *A Monkey Tale.* Doubleday & Co., 1929.

Feuillet, Octave. *Story of Mr. Punch.* E.P. Dutton & Co., 1929.

Camp, Ruth Orton. *The Story of Markets.* Harper & Brothers, 1929. (E)

Holway, Hope. *The Story of Water Supply.* Harper & Brothers, 1929. (E)

Hooker, Forrestine. *Garden of the Lost Key.* Doubleday, Doran & Co., 1929. (E)

Hader, Berta and Elmer. *What'll You Do When You Grow Up?* Longman's, Green & Co., 1929.

Stoddard, Anne. *A Good Little Dog.* The Century Co., 1930.

Williamson, Hamilton. *Baby Bear.* Doubleday, Doran & Co., 1930.

Williamson, Hamilton. *Little Elephant.* Doubleday, Doran & Co., 1930.

Whitney, Elinor. *Timothy and the Blue Cart.* Frederick A. Stokes, 1930.

Hader, Berta and Elmer. *Lions and Tigers and Elephants Too: Being an Account of Polly Patchin's Trip to the Zoo.* Longman's, Green & Co., 1930.

Hader, Berta and Elmer. *Berta and Elmer Hader's Picture Book of Mother Goose.* Coward-McCann, 1930.

Baruch, Dorothy. *Big Fellow at Work.* Harper & Brothers, 1930.

Hader, Berta and Elmer. *Under the Pignut Tree.* Alfred A. Knopf, 1930.

Bigham, Madge. *Sonny Elephant.* Little, Brown & Co., 1930.

Stoddard, Anne. *Bingo is My Name.* The Century Co., 1931.

Hader, Berta and Elmer. *The Farmer in the Dell.* The Macmillan Company, 1931.

Hader, Berta and Elmer. *Summer Under the Pignut Tree.* Alfred A. Knopf, 1931.

Holway, Hope. *The Story of Health.* Harper & Brothers, 1931. (E)

Williamson, Hamilton. *Lion Cub: A Jungle Tale.* Doubleday, Doran & Co., 1931.

Hader, Berta and Elmer. *Tooky: The Story of a Seal Who Joined the Circus.* Longman's, Green & Co., 1931.

Stoddard, Anne. *Here Bingo.* The Century Co., 1932.

Hader, Berta and Elmer. *Berta and Elmer Hader's Picture Book of the States.* Harper & Brothers, 1932.

Hahn, Julia Letheld. *Who Knows? A Little Primer.* Houghton Mifflin Co., 1932.

Lecky, Prescott. *Play-book of Words.* Frederick A. Stokes, 1933.

Hader, Berta and Elmer. *Chuck-a-Luck and His Reindeer.* Houghton Mifflin Co., 1933.

Hader, Berta and Elmer. *Spunky: The Story of a Shetland Pony.* The Macmillan Company, 1933.

Hader, Berta and Elmer. *Whiffy McMann.* Oxford University Press, 1933.

Miller, Jane. *Jimmy the Groceryman.* Houghton Mifflin Co., 1934.

Hader, Berta and Elmer. *Midget and Bridget.* The Macmillan Company, 1934.

Hahn, Julia Letheld. *Everyday Fun.* Houghton Mifflin Co., 1935.

Hader, Berta and Elmer. *Jamaica Johnny.* The Macmillan Company, 1935.

Dalgliesh, Alice. *The Smiths and Rusty.* Charles Scribner's Sons, 1936.

Hader, Berta and Elmer. *Stop. Look, Listen.* Longman's, Green & Co., 1936.

Hader, Berta and Elmer. *Billy Butter.* The Macmillan Company, 1936.

Hader, Berta and Elmer. *Green and Gold: The Story of the Banana.* The Macmillan Company, 1936.

Lee, Melicent Humason. *Marcos: A Mountain Boy of Mexico.* Albert Whitman Co., 1937.

Dalgliesh, Alice. *Wings for the Smiths.* Charles Scribner's Sons, 1937.

Williamson, Hamilton. *Humpy: Son of the Sands.* Dougleday, Doran & Co., 1937.

Lent, Henry Bolles. *The Farmer.* The Macmillan Company, 1937.

Hader, Berta and Elmer. *Tommy Thatcher Goes to Sea.* The Macmillan Company, 1937.

Hader, Berta and Elmer. *Working Together: The Inside Story of the Hader Books.* The Macmillan Company, 1937.

Moore, Clement Clarke. *A Visit From St. Nicholas.* The Macmillan Company, 1937. Happy Hour book.

Garrard, Phillis. *Banana Tree House.* Coward-McCann, 1938.

Hader, Berta and Elmer. *Cricket: The Story of a Little Circus Pony.* The Macmillan Company, 1938.

Williamson, Hamilton. *Stripey: A Little Zebra.* Doubleday, Doran & Co., 1939.

Hahn, Julia Letheld. *Reading for Fun.* Houghton Mifflin Co., 1939. (Co-illustrator Dorothy Handsaker)

Hader, Berta and Elmer. *Cock-a-Doodle-Doo: The Story of a Little Red Rooster.* The Macmillan Company, 1939.

Hader, Berta and Elmer. *The Cat and the Kitten.* The Macmillan Company, 1940.

McBride, Mary Margaret. *How Dear to My Heart.* The Macmillan Company, 1940.

Hader, Berta and Elmer. *Little Town.* The Macmillan Company, 1941.

Gaggin, Eva Roe. *Down Ryton Water.* The Junior Literary Guild and the Viking Press, 1941. (E)

Hader, Berta and Elmer. *The Story of Pancho and the Bull With the Crooked Tail.* The Macmillan Company, 1942.

Hader, Berta and Elmer. *The Mighty Hunter.* The Macmillan Company, 1943.

Mason, Miriam F. *Timothy Has Ideas.* The Macmillan Company, 1943.

Hader, Berta and Elmer. *The Little Stone House: A Story of Building a House in the Country.* The Macmillan Company, 1944.

Hader, Berta and Elmer. *Rainbow's End.* The Macmillan Company, 1945.

Hader, Berta and Elmer. *Skyrocket.* The Macmillan Company, 1946.

Hader, Berta and Elmer. *Big City.* The Macmillan Company, 1947.

Bechtel, Louise Seaman. *Mr. Peck's Pets.* The Macmillan Company, 1947.

Hader, Berta and Elmer. *The Big Snow.* The Macmillan Company, 1948.

Singmaster, Elsie. *Isle of Que.* Longman's, Green & Co., 1948. (E)

Hader, Berta and Elmer. *Little Appaloosa.* The Macmillan Company, 1949.

Hader, Berta and Elmer. *Squirrely of Willow Hill.* The Macmillan Company, 1950.

Hader, Berta and Elmer. *Lost in the Zoo.* The Macmillan Company, 1951.

Hader, Berta and Elmer. *Little White Foot: His Adventures on Willow Hill.* The Macmillan Company, 1952.

Hader, Berta and Elmer. *The Friendly Phoebe.* The Macmillan Company, 1953.

Hader, Berta and Elmer. *Wish on the Moon.* The Macmillan Company, 1954.

Hader, Berta and Elmer. *Home on the Range: Jeremiah Jones and His Friend Little Bear in the Far West.* The Macmillan Company, 1955.

Hader, Berta and Elmer. *The Runaways: A Tale of the Woodlands.* The Macmillan Company, 1956.

Hader, Berta and Elmer. *Ding Dong Bell: Pussy's in the Well.* The Macmillan Company, 1957.

Hader, Berta and Elmer. *Little Chip of Willow Hill.* The Macmillan Company, 1958.

Hader, Berta and Elmer. *Reindeer Trail: A Long Journey From Lapland to Alaska.* The Macmillan Company, 1959.

Hader, Berta and Elmer. *Mister Billy's Gun.* The Macmillan Company, 1960.

Hader, Berta and Elmer. *Quack Quack: The Story of a Little Wild Duck.* The Macmillan Company, 1961.

Hader, Berta and Elmer. *Little Antelope: An Indian for a Day.* The Macmillan Company, 1962.

Hader, Berta and Elmer. *Snow in the City: A Winter's Tale.* The Macmillan Company, 1963.

Hader, Berta and Elmer. *Two is Company, Three's a Crowd: A Wild Goose Tale.* The Macmillan Company, 1965.

Hader, Berta and Elmer. *Picture Book of Mother Goose.* Derrydale Books, 1987.

Hader, Berta and Elmer. *Chicken Little and the Little Half Chick.* Gallery Books, 1990.

Hader, Berta and Elmer. *Hansel and Gretel.* Smithmark Publishers, 1990.

Hader, Berta and Elmer. *Humpty Dumpty and Some Other Funny People.* Weiser & Weiser, 1990.

Hader, Berta and Elmer. *The Little Red Hen.* Smithmark Publishers, 1990.

Hader, Berta and Elmer. *The Story of the Three Bears.* Gallery Books, 1990.

Hader, Berta and Elmer. *The Ugly Duckling.* Stanley Rosen Associates, 1990.

Hader, Berta and Elmer. *A Visit From St. Nicholas.* Stanley Rosen Associates, 1990.

Hader, Berta and Elmer. *Wee Willie Winkie and Some Other Boys and Girls From Mother Goose.* Gallery Books, 1990.

Hader, Berta and Elmer. *Little Tootsie Paper Dolls.* Dover, 1990.

Dust Jackets by Elmer Hader

Don Coyote by Whitman Chambers

The Monk of Hambelton by Armstrong Livingston

The Perilous Night by Boyce Burke

Stronghold by Boyce Burke

Bright Avenue by Josephine Bentham

The Long Valley by John Steinbeck

Winter of Our Discontent by John Steinbeck

Grapes of Wrath by John Steinbeck

East of Eden by John Steinbeck

Ballad Makin' in the Mountains of Kentucky by Jean Thomas

The Ghostland by Fred Rothermell

Home is Here by Sidney Meller

Love in the Sun by Leo Walmsley

Mutiny Island by Charles M. Bennett

The River Between by Louis Forgione

A Ticket to Jamaica by Agnes and Richard Wright

Index

Page numbers in italics refer to illustrations.

Acknowledgments

Many assisted us with our researching, writing and production efforts. We are extremely grateful to them. Our thanks to: William Anderson, John Barrows, Chris Berner, Brian Booth, Jim Carmin, Sybilla Cook, Valarie Cooley, Bill Duncan, James Fox, Tamara Gerrard, Jack Geist, Bruce Glidden, Mark Goldstein, Judy Harm, Nora Harrison, Lindsey Horner, Robin Horner, Robert Leo Heilman, Cindy Hutchison, Brian Jennings, Ed Kemp, Elaine Kemp, Ann Kjensrud, Jessica Kuhnen, Lesli Larson, Bill Lee, Michael James Lessner, Linda Long, Leonard Marcus, Heidi O'Neill, Charles Read, Dean Rogers, Ellen Ruffin, Bruce Tabb, Terry Talley, Russell Tether, Lorraine Tolley, Don Vernon, Ursula Vernon, Jim Will, Andrea Wood, Marilyn Woodrich, and to the many other helpful and encouraging people along the path.